Collins

Learn to Paint

Sketch

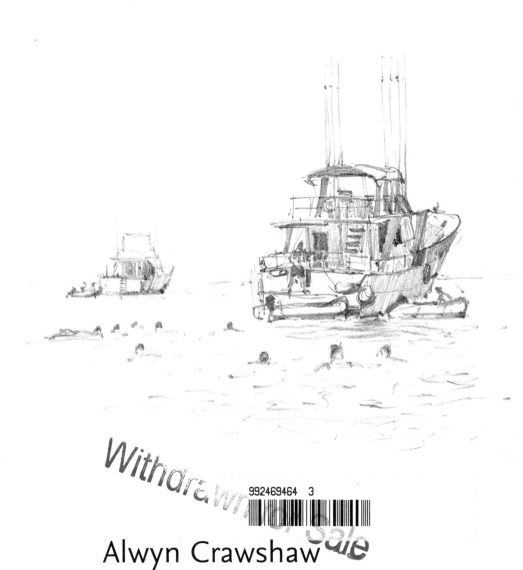

992469464 3

Alwyn Crawshaw

First published in 1983 by
William Collins Sons & Co Ltd, London
Reprinted 1984, 1985
New edition 1986, Reprinted 1987 (twice), 1989, 1990 (twice)

Reprinted by Collins, an imprint of
HarperCollins*Publishers*
77-85 Fulham Palace Rd
Hammersmith, London W6 8JB

The Collins website address is www.collins.co.uk
Collins is a registered trademark of HarperCollins Publishers Limited

New edition 1998

05 07 08 06 04
8 10 9

Designed, edited and typeset by Flicka Lister
Photography by Nigel Cheffers-Heard and Michael Petts

A catalogue record for this book is available from the British Library

ISBN 0 00 718297 X

Colour origination by Colourscan, Singapore
Printed and bound in Hong Kong

PREVIOUS PAGE: **Pleasure Cruiser** 15 x 10 cm (6 x 4 in)
THIS PAGE: **Point-to-Point Meeting** 19 x 40 cm (7 ½ x 17 in)
OPPOSITE: **Sarlat, Dordogne, France** 17 x 15 cm (7 x 6 in)

Contents

Sketch of an Artist

▲ Alwyn Crawshaw sketching outdoors.

Successful painter, author and teacher, Alwyn Crawshaw was born at Mirfield, Yorkshire and studied at Hastings School of Art. He now lives in Norfolk with his wife June, who is also an artist.

Alwyn is a Fellow of the Royal Society of Arts, and a member of the British Watercolour Society and the Society of Equestrian Artists. He is also President of the National Acrylic Painters Association and is listed in the current edition of *Who's Who in Art*. As well as painting in watercolour, Alwyn also works in oil, acrylic and occasionally pastel. He chooses to paint landscapes, seascapes, buildings and anything else that inspires him. Heavy working horses and winter trees are frequently featured in his landscape paintings and may be considered the artist's trademark.

This book is one of eight titles written by Alwyn Crawshaw for the HarperCollins *Learn to Paint* series. Alwyn's other books for HarperCollins include: *The Artist At Work* (an autobiography of his painting career), *Sketching with Alwyn Crawshaw*, *The Half-Hour Painter*, *Alwyn Crawshaw's Watercolour Painting Course*, *Alwyn Crawshaw's Oil Painting Course*, *Alwyn*

Crawshaw's Acrylic Painting Course and *Alwyn & June Crawshaw's Outdoor Painting Course.*

To date Alwyn has made seven television series: *A Brush with Art, Crawshaw Paints on Holiday, Crawshaw Paints Oils, Crawshaw's Watercolour Studio, Crawshaw Paints Acrylics, Crawshaw's Sketching & Drawing Course* and *Crawshaw Paints Constable Country*, and for each of these he has written a book of the same title to accompany the television series.

Alwyn has been a guest on local and national radio programmes and has appeared on various television programmes. In addition, his television programmes have been shown worldwide, including in the USA and Japan. He has made many successful videos on painting and is also a regular contributor to the *Leisure Painter* magazine and the *Australian Artist* magazine. Alwyn and June organize their own successful and very popular painting courses and holidays. They also co-founded the Society of Amateur Artists, of which Alwyn is President.

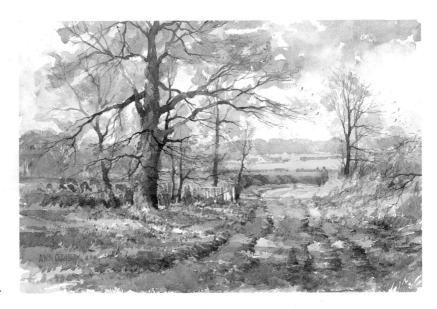

▲ **Welly Weather**
Watercolour on Waterford watercolour paper, Rough 38 x 50 cm (15 x 20 in)

Alwyn's paintings are sold in British and overseas galleries and can be found in private collections throughout the world. His work has been favourably reviewed by the critics. *The Telegraph Weekend Magazine* reported him to be 'a landscape painter of considerable expertise' and the *Artists and Illustrators* magazine described him as 'outspoken about the importance of maintaining traditional values in the teaching of art'.

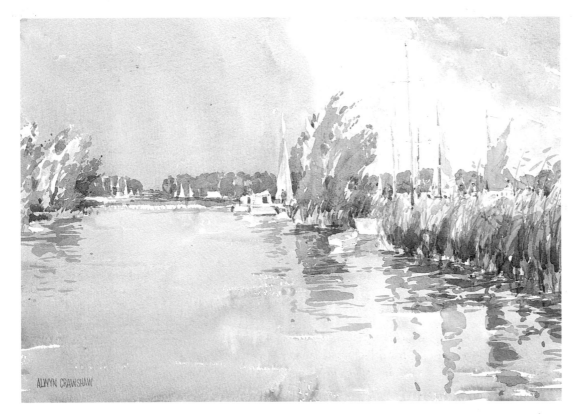

◄ **Reflections on the River Thurne, Norfolk**
Watercolour on Waterford watercolour paper, Rough 38 x 50 cm (15 x 20 in)

Introduction

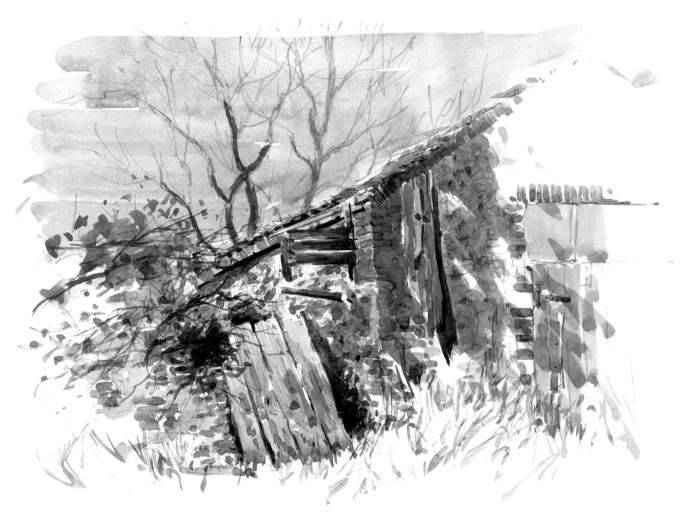

The sketch is the beginning. Almost all work that has been created on paper, canvas, clay, stone, metal, or indeed any artist's medium, started as a sketch. An idea can be stimulated by a thousand things, but a sketch can hold it for all time and be used as a foundation for other work, even though the idea may represent only a fleeting moment of inspiration. Therefore I feel strongly, and I repeat several times throughout this book, that you should never throw a sketch away, no matter how small or insignificant you think it is. You have created something that is unique and original from which you can always learn or work from, even years later.

Seeing things differently

In this book, I want to teach you how to sketch out of doors and how to use your sketches either as works in their own right or as training exercises for drawing and painting. This will enable you to build on the knowledge you already have or, if you are a beginner, will open your eyes to new sights that can be experienced only when you look around you with sympathetic and observant eyes. You will 'see' things in a new light. You could even look at a telegraph pole and wonder at its beauty! Perhaps when you reach this stage, you should keep your thoughts to

▲ **Spring Sunlight, Saltham, Norfolk**
2B pencil and watercolour on cartridge paper
28 x 40 cm (11 x 16 in)

yourself for a while. People often think that artists are a little different (I hasten to add we are not) and placing a telegraph pole on a pedestal might add fuel to that thought!

It is interesting that we always tend to think of ourselves as the normal ones whatever profession, sport or pastime we indulge in. On one very cold day I went sketching at Exmouth. My wife, June, was with me and we walked along the banks of the river Exe estuary looking for a sketching spot.

The sea was very shallow and covered with windsurfers skimming across the water. They were falling in, getting up, and falling in, over and over again. Although they had wet suits on, they looked extremely cold – we thought they were mad! Further along we saw two bundles of clothing on the stony beach with what looked like antennae sticking out. When we were closer a head peeped out and said: 'Good afternoon'. They were anglers, fishing quite merrily on such a bleak, cold day.

Eventually I found a suitable spot and started to sketch the scene in front of me. The wind was so biting that I was only able to keep going for about 20 minutes. June had gone for a walk to try to keep warm. When I had almost finished, one of the fishermen came over and looked at my ungloved right hand, which was blue with cold and said: 'You must be crazy sitting out here drawing a picture.'

The strange thing is that I had assumed I was the normal one and that all those other people were the odd ones! The sketch I did on that occasion was drawn with a 2B pencil on cartridge paper *(see below)*.

I am not suggesting you go out and find the coldest spot and stick it out for 20 minutes. What I want you to be able to do after reading this book is to go out with confidence and enjoy sketching. I enjoy sketching just as much, or even more sometimes, than sitting in my studio painting a 'masterpiece' (my interpretation!). One of the greatest advantages is that it provides a reason to go outdoors and enjoy your surroundings.

First things first

I have tried to write this book in a logical order but there is so much to say almost at the same time that it can be difficult. For instance, which comes first, the section on design, or notes on perspective, how to use a pencil, or what types of sketch to do? To overcome this, I suggest you read the book through first before you start sketching yourself – even though at times it may seem as though the cart is being put before the horse!

All the sketches in the book, except for the exercises and demonstrations, are reproduced from my sketchbooks and they were all done

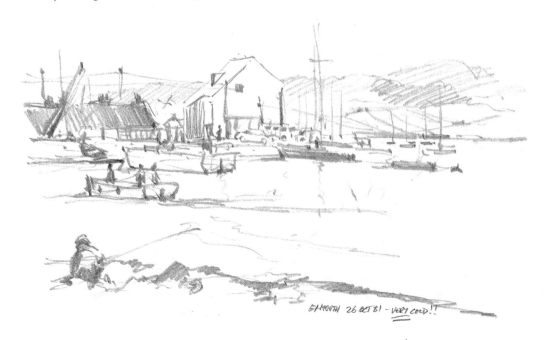

◄ **Exmouth Harbour**
2B pencil on cartridge paper
17 x 28 cm (7 x 11 in)
This is the sketch I did on that very cold day at Exmouth – when I believed the only normal people in the world were artists!

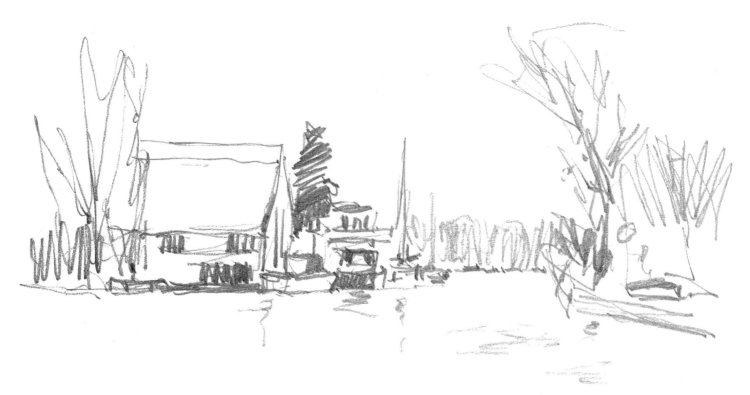

on location. Some were done especially for the book while others are examples of my work over the past few years. This should give you a broad 'picture' of sketching and a variety of subjects. In fact, each sketch tells me a story, so I feel as though I am opening the pages of my private sketching life and sharing it with you. I hope that by so doing you will learn from my artistic experiences!

What is a sketch?

Let's get back to the drawing board. We know that a sketch is the beginning, but what exactly is meant by the word 'sketch'? Artists use it in so many different ways.

A quick sketch can mean anything from something that is carefully observed and created with only a few lines, to a painting that hasn't made the grade in the artist's eyes. They then say: 'It's just a quick sketch!', using it as an excuse to cover up a poor painting!

Some artists take only a sketchbook and pencil with them when they go out sketching, while others take everything they can think of – easel, canvases, paints, seat, small table, umbrella, etc., and yet still use the phrase: 'I'm going out sketching'. Basically, what they really mean is that they are going out to draw

or paint a picture. In fact, I often use the expression myself, and I might end up with a finished watercolour painting instead of a watercolour sketch.

However, as we are interested in sketching in its 'real' sense, I have defined the word, from the artist's point of view, to help you through the book. After a lot of careful thought, I have broken down the sketch into four distinct and practical types.

The first type is an *enjoyment sketch*. This is a drawing or painting worked on location, done simply to enjoy the experience.

▲ **Horning, Norfolk**
2B pencil on cartridge paper
12.5 x 25 cm (5 x 10 in)
A typical enjoyment sketch. The scene inspired me and, as always, I had my pad and pencil ready.

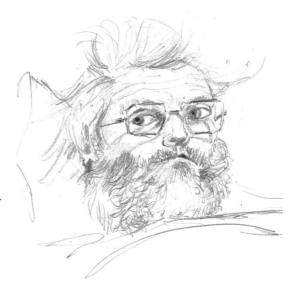

◄ **Self-portrait**
2B pencil on cartridge paper
22 x 28 cm (8½ x 11 in)
Although I was suffering from a slipped disc at the time, this qualifies as an enjoyment sketch! I did it with the aid of a mirror propped up on the bed. I wasn't aware of the scowl on my face as I drew it but now realise what June had to put up with for nearly two whole weeks!

The second type is an *information sketch*. This is a drawing or painting done solely to collect information or detail, which can be used later at home or in the studio.

The third type is an *atmosphere sketch*. This is a drawing or painting worked specifically to get atmosphere and mood into the finished result. It can then be used later for atmosphere and mood information, or as inspiration for an indoor painting.

Finally, I call the fourth type of sketch a *specific sketch*. This is a drawing or painting done of a specific subject to gather as much detailed information as possible, but which also conveys the atmosphere and mood of the occasion. The sketch is then used as the basis for a finished studio painting. The specific sketch is really a combination of the

information and atmosphere sketches, but the only difference is that the object is to go to a specific place to record what you see and feel, and then use all the information for a larger studio painting.

All sketches, whether they are drawings or paintings, can be used as 'finished' works of art. In fact, some artists' sketches are preferred to their finished paintings.

On the next pages, we will look in more detail at these four different types of sketches. As each one has its own special purpose, when you go out you may have a preconceived idea of what type of sketch you are going to do. If you haven't, then go out and do an enjoyment sketch. Get together your sketching equipment and set off, looking at your surroundings with your

▼ **From Deyá Beach, Majorca**
2B pencil on cartridge paper
20 x 28 cm (8 x 11 in)
I drew this enjoyment sketch while sitting on the beach in my swimming trunks. This was a complicated drawing for such a hot day – it was 90 degrees in the shade!

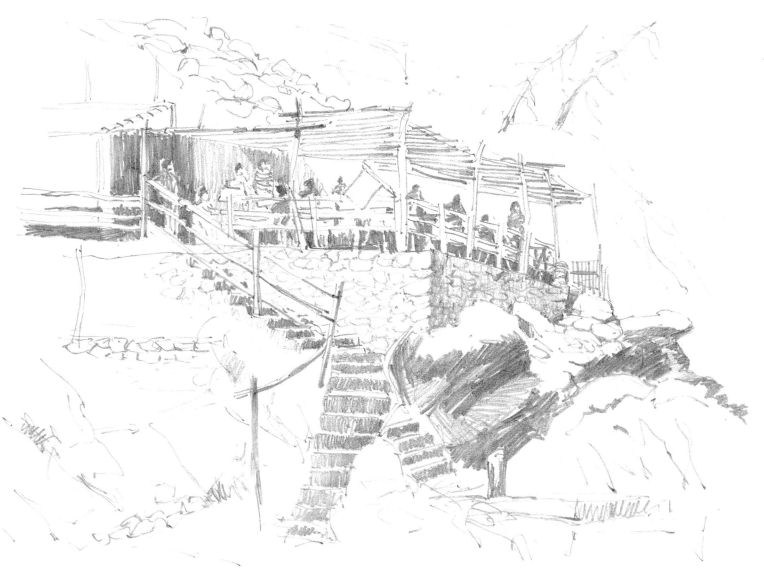

sketchbook in hand. This will give you the perfect excuse to wander around and really soak in the atmosphere or the visual beauty of things around you. Whether you are in an industrial town, or a village, on a beach or in the countryside, your subconscious will be working overtime, storing information for the future – but don't forget to sketch!

Remember that everything we see is stored away in our visual memory banks forever. We only need a trigger to bring a picture flooding back in seconds. If someone asks you if you were fortunate enough to watch man's first landing on the moon, that would be the trigger and within a second you could recall those television pictures in your mind's eye. If you are an artist and have created a sketch of a scene, the sketch will always be your trigger or reminder of the scene. The sketch is also an everlasting visual reference to keep for journeys down memory lane.

Enjoyment sketches

An enjoyment sketch contains information, even if it is only to show how good your technique was – or how bad. It can be used to help you improve it next time or simply to serve as a reminder of how much you enjoyed the day out, so it doesn't matter how poor the sketch was. When you've been sketching and had a marvellous time, ask yourself if you would have gone out on that occasion if you hadn't had sketching as an excuse!

With your pencil and sketchbook handy, you can enjoy yourself anywhere. I did the sketch of ducks, shown at the top of the page, when I literally had a few minutes to spare. I did the boats, shown at the bottom of the next page, on the same day.

Information sketches

The information sketch really speaks for itself. Its aim is to gather information which can be used later in the studio, usually to work on a larger picture. Naturally you will have your own ideas on what information you need but remember, it is no good going home and leaving your subject without enough information, since you may never see it again.

Points to remember

Information to include on your sketch are the position of the sun, the position of shadows, the sizes and positions of important areas, such as a boat, building, tree, lamppost, people, etc., and their position in relation to each other. This is very important and I have written a section on how to 'measure from life' and transfer a scene on to paper, on page 34.

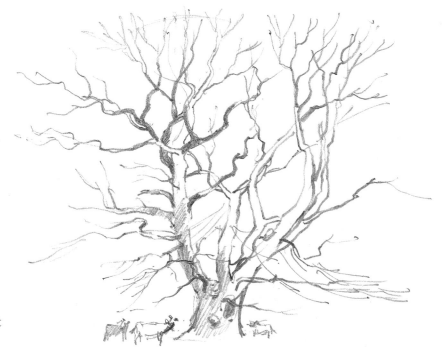

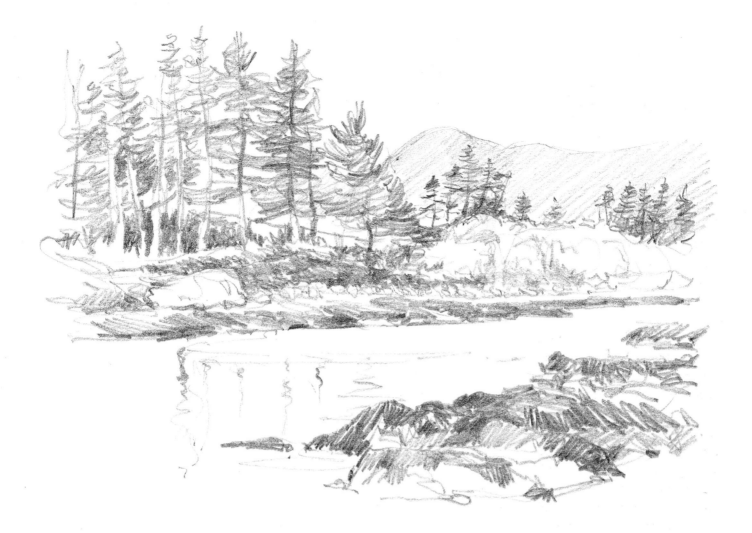

Show scale

Make sure you put something in your sketch to give an idea of scale. In the drawing of the trees *(left)*, the scale was shown by the sheep. The information I was after was of the trees not sheep, or I would have drawn them larger and, of course, in greater detail. Incidentally, I don't think they look very much like sheep, but they do give me the information I need!

Make colour notes

If you are working in black and white then you will need to make colour notes. Make yourself a code, for instance, DG = dark green, PF = ploughed field, LR = light red, and so on. This is very important. A week later when you look at your sketch, it is easy to forget whether a roof was red or blue slate.

However, when you do a watercolour sketch don't put any comments or coding on it. Because of the relaxed manner in which it is approached, a watercolour sketch can often turn out to be a perfect watercolour painting. If you need notes, put them lightly on the back in pencil, or on another piece of paper.

Atmosphere sketches

The important element to capture in an atmosphere sketch is the feel of the subject in its environment. If you were sketching a town scene, the type of day is not the only component of atmosphere. You would have to capture such things as the mood of the

▲ **Parknasilla, Ireland**
2B pencil on cartridge paper
20 x 28 cm (8 x 11 in)
Make sure you mark the position of the sun on all your information sketches. I forgot to do it on this one!

▼ **Dinghies**
2B pencil on cartridge paper
4 x 17 cm (1½ x 7 in)
I did these enjoyment sketches from a moving boat. It certainly keeps your hand and eye in!

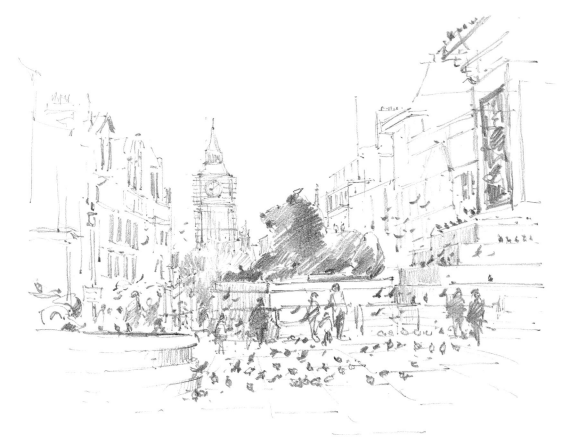

◀ **Trafalgar Square, London**
2B pencil on cartridge paper
20 x 28 cm (8 x 11 in)
I did this sketch to capture the atmosphere of people and pigeons. Trafalgar Square is always full of both!

streets, whether busy or quiet, crowded pavements, wind-blown leaves, tree-lined pavements, etc. I suppose you could say that it is an information sketch gathering atmosphere information. But in general the detail is not there, that is left to the imagination or an information sketch.

Specific sketches

I always mention the specific sketch last because in a way it embodies the other three: you should enjoy it as well as collecting information and capturing atmosphere. The main difference is that the place and time are usually dictated to you and this means some careful planning.

Are you sketching comfortably?

Let us now think about actually leaving home and going out sketching. The most important thing is you. You can't relax and work outside if you are cold. Remember that you can always take clothing off to cool down but you can't

put more on if you haven't got it with you. Being comfortable is very important, too. There's enough to worry about when drawing a sketch, without trying to balance on a wobbly fence, or with your wellington boots sinking deeper into mud with every passing minute! Of course, some sketches can only be done in difficult positions – and there is always someone who will try to do them – but try to find somewhere else where you are more comfortable until you are experienced.

Subject matter

If you are like me, when you know you are going out sketching, you will often have a preconceived idea of what you want to draw. So, when you get to your starting-off point and you can't find what you had in mind you can become very frustrated.

The only answer is to empty your mind completely of what you thought you might do and look around at what is available. Usually you then see your surroundings totally differently, and can find a subject.

Don't go round the next corner!

This is a universal problem. You see a sketching spot and think, 'That's it!' Then you think it may be better round the next corner but, when you get there, you have the same thought again. And so it goes on until you run out of corners and views and an hour later you find your way back to the point you first started from, and decide that after all it's the best position! By that time you have probably lost an hour of daylight and you are exhausted before you start. Believe me, I'm not exaggerating. I have done it and it takes a lot of willpower to stay at your first spot.

The answer is to discipline yourself. If a scene inspires you, then draw it! Once you have sketched it, if you have the time, go round the next corner and have a look. If you find a better scene there, you can blame me. But don't forget to thank me on all the occasions when you find that the first spot that inspired you turns out to be the best!

Travelling light

I cover the equipment you should use later in the book. However, always remember to keep things to a minimum. You won't get very far loaded up like a human removal van!

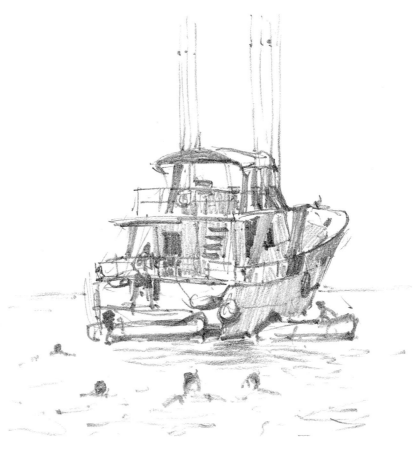

▲ **Pleasure Cruiser**
2B pencil on cartridge paper
15 x 10 cm (6 x 4 in)
I did this enjoyment sketch at Deyá, Majorca.

▼ **Face Lift, Westminster Bridge**
2B pencil on cartridge paper
28 x 40 cm (11 x 16 in)
I used this specific sketch, together with a photograph that I took of the scene, to do an acrylic painting later back at home.

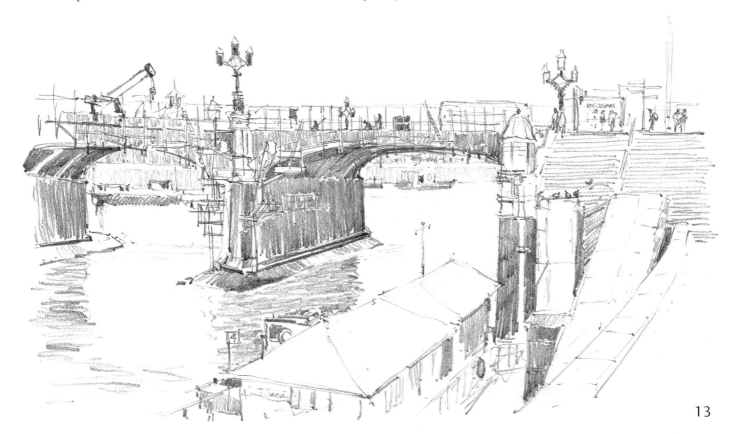

Simple Perspective

You don't need to know everything about perspective to be able to paint or sketch a picture. But I believe, your sketching will become easier and the result more convincing if you know the basics of perspective.

When you look out to sea the horizon will always be at your eye level, whether you are on a clifftop or lying flat on the sand. So the horizon is the eye level (EL). Of course, if you are in a room there is no horizon, but you still have an eye level. To find it hold a pencil horizontally in front of your eyes at arm's length. Your eye level is where the pencil hits the opposite wall. If two parallel lines were marked out on the ground and extended to the horizon, they would come together at what is called the vanishing point (VP). This is why railway lines appear to get closer together and finally meet in the distance – they have met at the vanishing point.

The basic rules

The page opposite really isn't as complicated as it looks. Let's go through it in stages. I started by drawing a straight line across to represent the eye level (EL). You should do the same. Next draw the red square shown in fig. **1**. Put a mark to the left at eye level, and use it as your vanishing point (VP). Then start to turn the

When out sketching, find your eye level by holding your pencil horizontally at arm's length in front of your eyes. Then draw it in on your sketchpad, position your centre of interest and work from there

square into a cube by drawing lines from the VP to both its left-hand corners. You can see that, having reached the same stage in fig. **2**, I've then joined up the right-hand corners to the VP to form two sides.

Copying my fig. **3**, draw a line between the top and bottom guidelines parallel to the left side of the square (see points **a** and **b**). This gives one side of a box . Then draw a horizontal line from point **a** to link with the guideline on the other side of the box at point **c**, and the same again, starting at **b** and drawing a horizontal line to the lower guideline at point **d**. Finally, join up points **c** and **d** with a perpendicular line. You will now have a cube and have succeeded in representing a three-dimensional object on a two-dimensional surface (your paper) with basic perspective theory using eye level and vanishing point.

In fig **4**, I have turned the cube into a house, by adding a roof. To find the centre of a square or cube, whatever its proportions, draw two diagonal lines from corner to corner. Where they converge is the centre. From this point I drew a guideline up to meet another line drawn from the VP to the point of the roof. Where these two lines cross is the apex of the roof. The house has two vanishing points, one on the left and one on the right. The principle is the same as for the first cube you drew, except the lines on both sides of the cube meet at a vanishing point.

I have drawn a 'bird's eye view' in fig **5**, by putting the eye level higher. Fig. **6** is just the opposite – a 'worm's eye view'. The eye level is very low, in fact, at ground level. Parallel lines meet at the VP and this includes windows, windowsills, doors, gutters, pavements, the line of lampposts – everything!

Please read this page very carefully and practise. It will help you to 'see' perspective when you are sketching.

▶ Practise the work on this page. Try drawing houses with your eye level at different heights and the vanishing points in different positions. This will quickly help you to understand this basic rule of perspective.

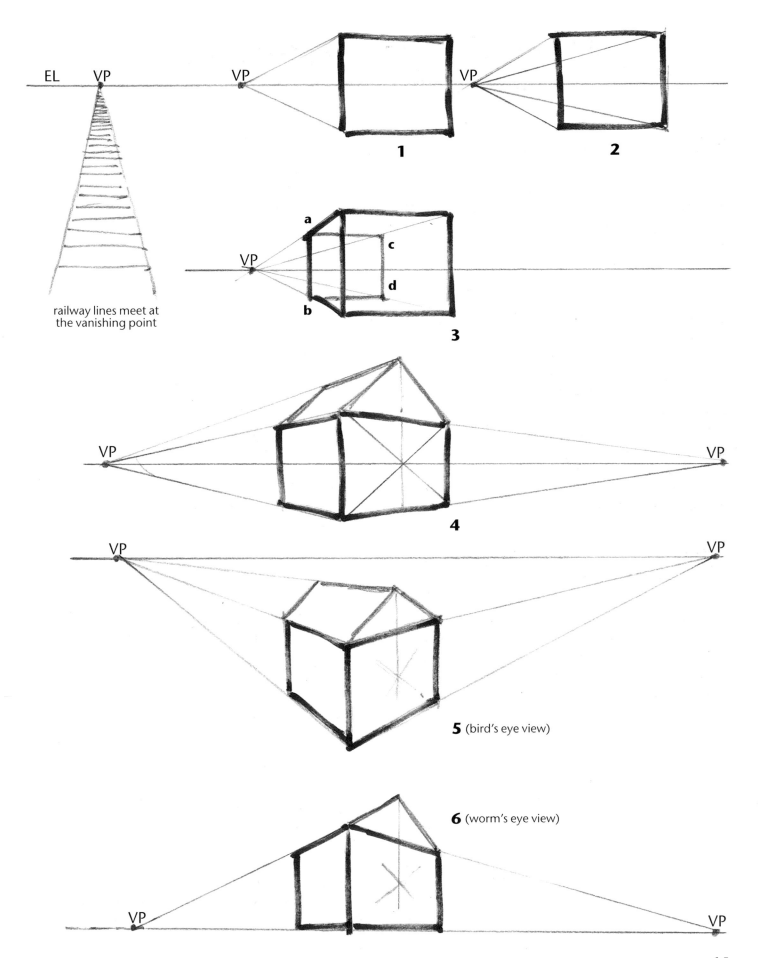

EL VP

railway lines meet at
the vanishing point

1

2

3

4

5 (bird's eye view)

6 (worm's eye view)

Design and Composition

Design is so much a matter of personal observation, that it is difficult to say what is good or bad. We don't always know, when we like a picture, how much the design and composition influence us. It may be the subject or the colours that attract us but, as far as sketching is concerned, take it from simple beginnings and let your instinct guide you with the help of some basic rules.

Basic rules

I have called this section Design and Composition because to me, in painting, they mean the same thing, namely: the positioning of objects on paper in a 'happy' way that enables you to tell a story visually to the onlooker. Let us start with a very old system I was taught at art school, which is now second nature to me. Although it is a good rule of thumb to work to, don't be stereotyped into sticking rigidly to rules. We are all individuals and a deviation from the expected to a more personal choice can make an original and sometimes unusual picture.

Focal points

In each of the illustrations (right), I have divided the paper into thirds, vertically and horizontally. Where they cross at points **a**, **b**, **c** and **d**, I have called the focal points.

If your centre of interest is positioned on or around a focal point as in the second sketch, then you should have a good design.

Look at the two people standing on the cliff in the third sketch and you will see that the composition looks 'happy'. (By that I mean it works well.)

Now look at the fourth sketch, where the two figures are still on the cliff, but now in the centre of the picture. It looks uninteresting and characterless.

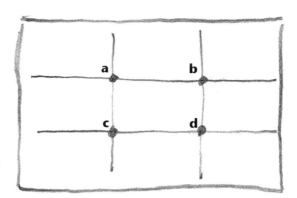

◀ Divide your picture into thirds, **a**, **b**, **c**, and **d** are the focal points.

◀ In this sketch the centre of interest is positioned at focal point **d**.

◀ The two people are positioned at focal point **a**. This is good.

◀ These two people are in the centre of the picture. This is not good composition.

Starting at the centre of interest

When you are composing a landscape or seascape, always have the horizon above or below the centre of the paper, never in the middle. Start by putting in your centre of interest at your chosen focal point, then work away from it. You will find that nature's lines, if observed carefully – hedgerows, rivers, roads and so on – will help to bring the picture together and form a natural design.

Making a picture finder

If your subject is large, such as a landscape or a village square and you can't decide which part to sketch, cut a mask out of thin card with an opening of about 10 x 8 cm (4 x 3 in). Hold up your masking card (picture finder) at arm's length and look, with one eye closed, through the mask 'window', see the illustration *(right)*. Move it around slowly up and down and backwards and forwards until you see a 'picture' that fires your imagination. Make mental notes of where your arm is and where the key points of the scene hit the edge of the mask. Mark these on your sketchpad and away you go!

Eventually design will come naturally as you progress and develop your own style, and the more you sketch the sooner your design will become second nature.

Collecting information

My little sketch of Val André *(below right)* shows the advantage of drawing plenty of information onto your sketch. Although it is simple, it gives me enough information to be able to work from at home – enough for two different pictures, in fact!

▶ This illustration shows two interesting ways of using one sketch. The blue outline shows the island as the centre of interest (at focal point **a**). The red outline gives a different view, with the two main foreground figures as the centre of interest (at focal point **c**). If I painted using the second outline, I would use strong local colour to emphasise the figures as the island could be overpowering.

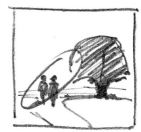

▶ These little sketches show simple designs using different focal points. The centre of interest can always be made to stand out from its immediate surroundings – for example, by using contrast when working in black and white, or vivid or different colours when working in colour.

▼ A picture finder will help you to decide which part of a landscape to paint.

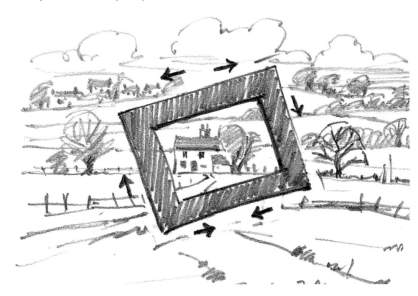

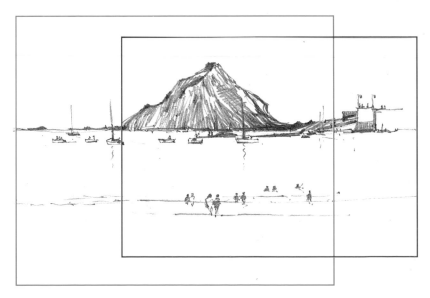

Working in Pencil

The most important piece of sketching equipment is the pencil. We tend to take the pencil for granted and it is not surprising. We all have one, somewhere. A good artist's drawing pencil has 13 different degrees of lead. The middle one, and the most common for everyday use, is HB. For general sketching purposes I use a 2B, which is a softer pencil, and sometimes a 3B, which is softer still.

Your basic sketching kit

All you need to get started are a 2B pencil, a putty eraser and a sketchpad. For me, this is the most versatile and pleasant way to sketch. It is also the least expensive. At least 60 per cent of my outdoor sketching is done with a pencil on a Daler-Rowney A4 or A3 cartridge paper sketchpad. You can also use a pad of layout paper. This is a strong, thin paper that has a good surface for pencil work. It is also less expensive than cartridge paper and is excellent for practising.

Staying sharp

It is important to get the most out of your pencil and the first thing to learn is how to sharpen it to get the best results. Use a sharp knife and cut off controlled positive slices, making a long, gradual taper to the lead.

A putty eraser is a very important part of an artist's sketching kit. Always keep one handy and never be afraid to use it for rubbing out!

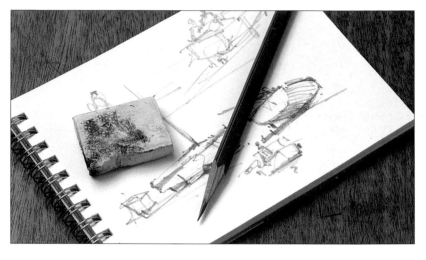

▲ Basic pencil sketching set.

◄ Use a sharp knife to sharpen your pencil to give a long point.

◄ The first pencil is sharpened correctly. The second one is sharpened to a flat chisel-shaped end which is good for shading. The third pencil is sharpened badly and would be difficult to draw with. I borrowed it from one of my new students!

◄ To protect pencil points, secure them to a piece of thick card with rubber bands, or make a cover for the lead by rolling some cartridge paper around the pencil and winding masking tape around it.

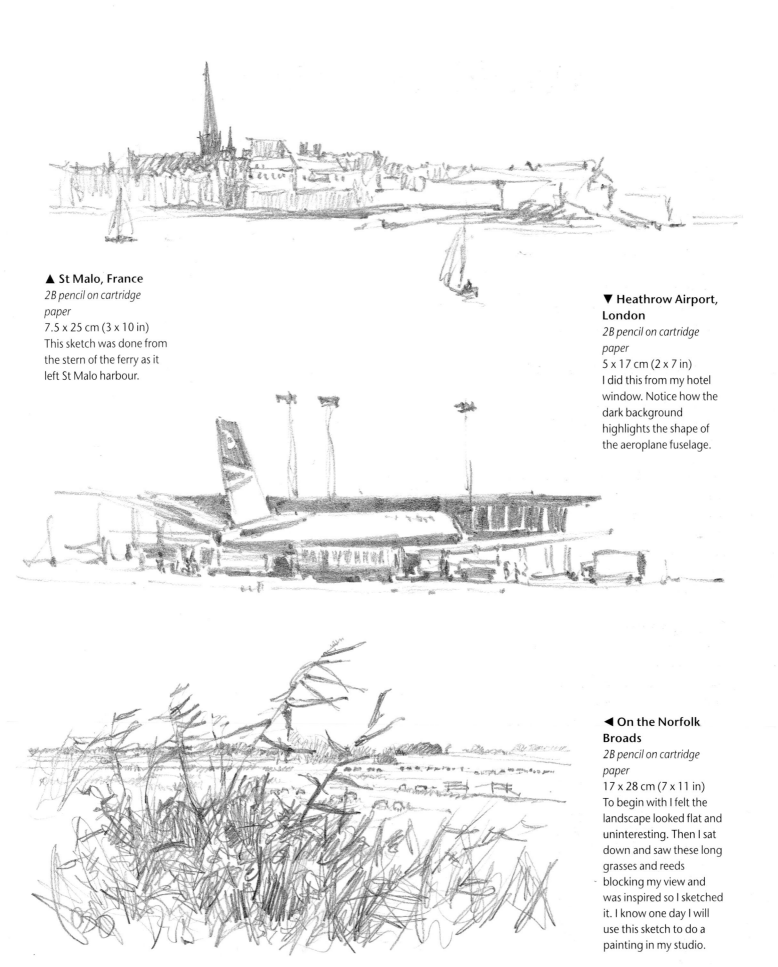

▲ St Malo, France
2B pencil on cartridge paper
7.5 x 25 cm (3 x 10 in)
This sketch was done from the stern of the ferry as it left St Malo harbour.

▼ Heathrow Airport, London
2B pencil on cartridge paper
5 x 17 cm (2 x 7 in)
I did this from my hotel window. Notice how the dark background highlights the shape of the aeroplane fuselage.

◄ On the Norfolk Broads
2B pencil on cartridge paper
17 x 28 cm (7 x 11 in)
To begin with I felt the landscape looked flat and uninteresting. Then I sat down and saw these long grasses and reeds blocking my view and was inspired so I sketched it. I know one day I will use this sketch to do a painting in my studio.

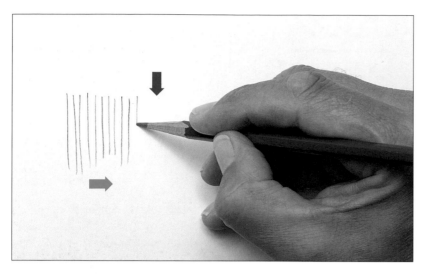

▲ 'Short' drawing position

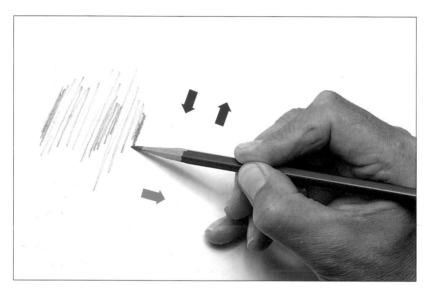

▲ 'Long' drawing position

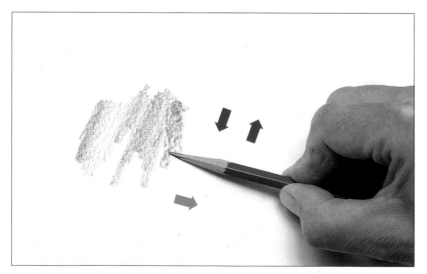

▲ 'Flat' drawing position

Holding your pencil

Most of us have used pencil or pens for writing since childhood and unfortunately, old habits die hard. To sketch successfully, you must learn to hold your tools for sketching in several different ways. In the photographs showing pencil holds you will see two types of arrow. The red arrow shows the direction of the the pencil strokes, and the blue arrow shows the direction in which the pencil is travelling over the paper. I use these arrows throughout the book.

The 'short' drawing position
The way one holds a pencil for writing is fine for controlled drawing and careful line work

The 'long' drawing position
However, for a more free and flowing movement, especially needed in working the sketch over a large area, you must hold your pencil at least 7.5 cm (3 in) from the point and have the pencil at a flatter angle to the paper. This 'long' drawing position (see the second example) will give more versatility to the pencil strokes.

The 'flat' drawing position
This is a totally different way of holding your pencil. The pencil is almost flat on the paper, held off by your thumb and first finger, which allows you to touch and move over the surface. This way of working your pencil allows you to work in fast broad strokes, using the long edge of the lead to give large shaded areas.

Doodle to practise!
With these three positions there are infinite variations. Using these as a base, learn to work with a pencil, all over again. Practise whenever you can – doodle, do anything. Don't worry about drawing, just get used to the pencil and what you can make it create on paper. Don't worry about rubbing anything out, either. Taking away what you don't want is as important as putting your drawing in.

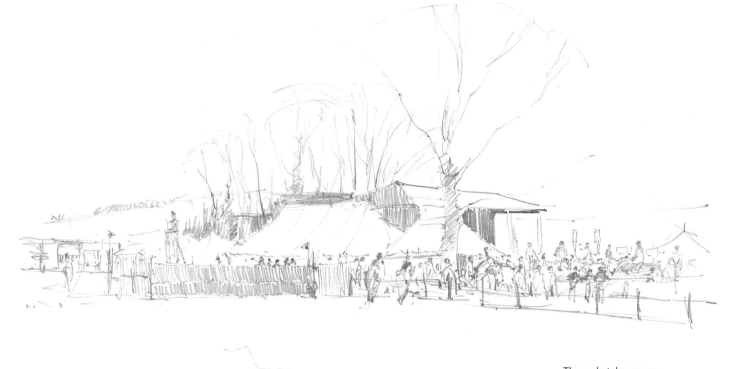

These sketches were drawn on cartridge paper twice the size they are reproduced here. I did the one above at a local point-to-point meeting. The one on the left was done at the Blackpool Tower Ballroom and the sketch below became a demonstration for students during a coffee break on a painting holiday in France.

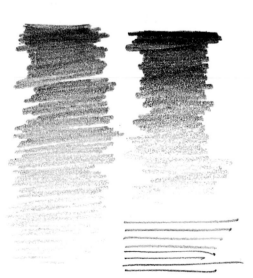

▲ Here I have shown the tonal ranges of a 2B pencil (on the left) and a 3B pencil (on the right).

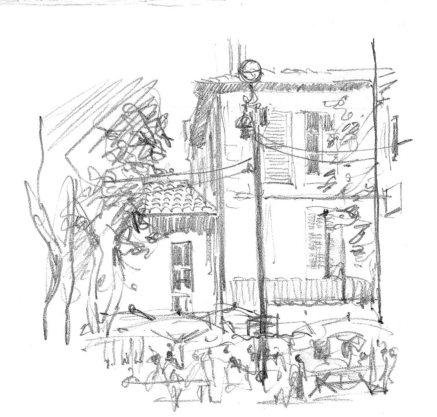

Working in Pen and Ink

For a basic ink sketching set you need a sketching pad and a pen. But with so many pens on the market, which one should you choose? The thickness of the nib, and the line it creates, is very much a matter of personal preference, as is the general design of the pen. Look for one that feels well-balanced and is comfortable to draw with. Also make sure that it is waterproof so that, should you decide to turn your drawing into a pen and wash painting, you will be able to paint over your pen marks without any fear of them running.

Dip-in pens

The mapping pen has a nib that gives a very fine point and is used universally for fine pen drawings. You can buy various types of drawing nibs and these are all 'dip-in-ink' pens. This means for sketching you must take with you a bottle of waterproof drawing ink.

Experiment with different nibs to start with and get the feel of working with them. Don't be afraid of them, they are more flexible and stronger than you imagine, but if you press hard on an upstroke you could damage the nib. You need a hard surface paper or board for fine nib work and the Daler-Rowney Drawing Book containing Ivorex board is perfect for the purpose.

A pen is a good medium to teach you to sketch decisively – the more you practise, the more positive your drawings will become.

▲ My basic ink sketching kit contains a sketchpad, waterproof ink, a mapping pen, ballpoint pen and a Uni-Ball Signo marker pen.

Easier options

Nowadays, drawing marker pens, with varying nib sizes, are used by many artists. They are more convenient because you do not have to dip them in ink. For all my outdoor pen sketching, I use this type of marker pen – normally either a Uni-Ball Signo or Uni Pin Fine Line Marker.

Try using a ballpoint pen as well. The results can look a little mechanical, but there are quite a few advantages. It is inexpensive, you don't have to dip it in ink or fill it, and you usually have one in your pocket. It definitely makes a very good standby sketching tool in an emergency.

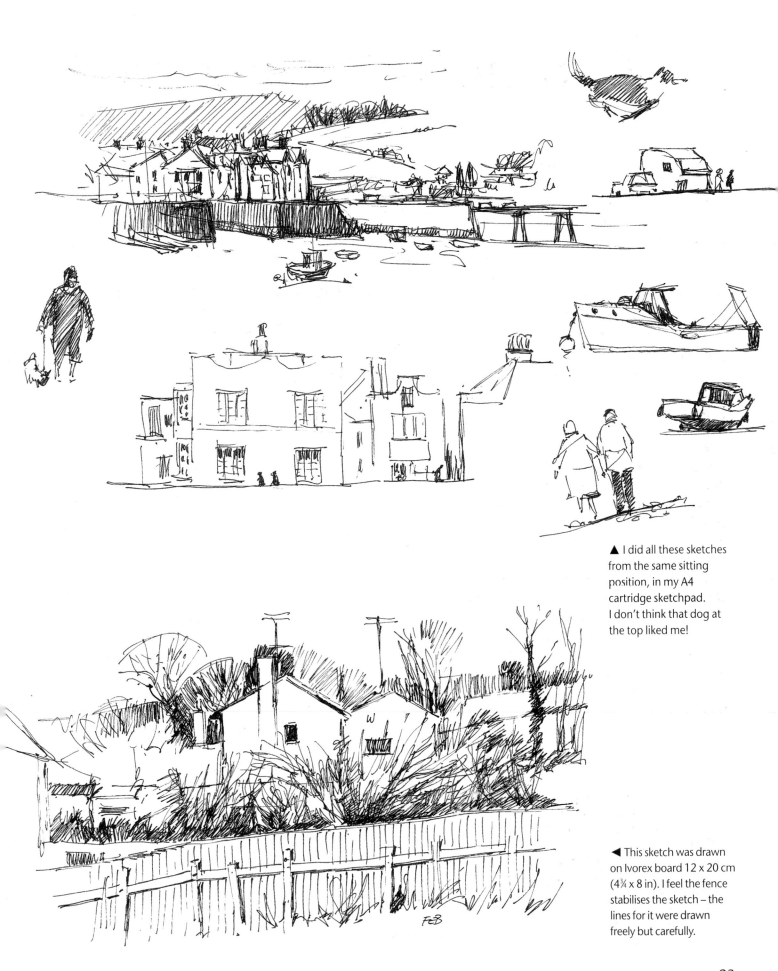

▲ I did all these sketches from the same sitting position, in my A4 cartridge sketchpad. I don't think that dog at the top liked me!

◀ This sketch was drawn on Ivorex board 12 x 20 cm (4¾ x 8 in). I feel the fence stabilises the sketch – the lines for it were drawn freely but carefully.

Charcoal and Conté Pencil

You can have lots of fun sketching with smudgy materials like charcoal and conté pencils, both of which have been used by artists for centuries. Experiment and practise!

Working with charcoal

Charcoal is not the medium for the fussy, neat and careful worker. It is for broad, adventurous sketching, where one stroke can cover a lot of paper. It is exciting to use, especially for atmosphere sketches of landscapes, since skies can be put in quickly, and large masses of land can be worked covering your paper rapidly with tonal areas You can also use your finger to smudge it to get tonal effects.

However, since charcoal does smudge so easily, you will have to practise working with your hand not resting on your paper. Always fix your finished work with a spray fixative.

Charcoal can be worked on almost any paper, but I suggest you use cartridge paper at first. Charcoal can be bought in different grades, in stick or pencil form. You have more freedom using a stick, since you can use the long edge for broad shading, but a pencil is cleaner and easier to use.

The basic sketching set shown here offers a choice. You can take a charcoal pencil, sketchbook and putty eraser (note: it is not always easy to rub out charcoal), or sticks of charcoal instead of the pencil, or both. Even so it is a small and easy sketching set to carry.

Working with conté pencil

Conté pencils also come in sticks and are similar to charcoal but harder. Your sketching set is simple – pencil or sticks and a sketchpad. As with charcoal, conté can smudge and can't always be rubbed out.

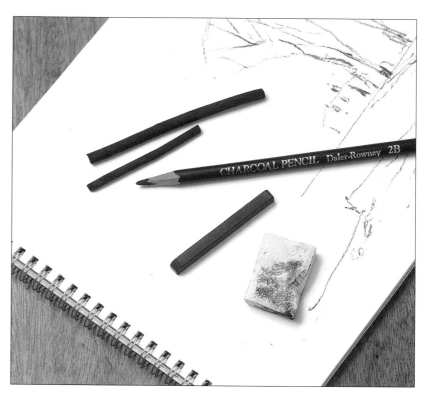

▲ Basic charcoal and conté pencil sketching kit.

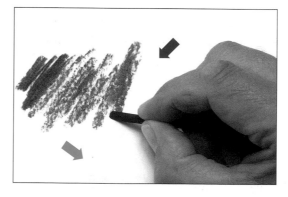

◀ For shaded work, use the flat, blunt end of your charcoal stick.

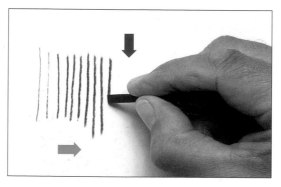

◀ To draw thin lines, simply find an edge on the end of the stick and only use light pressure.

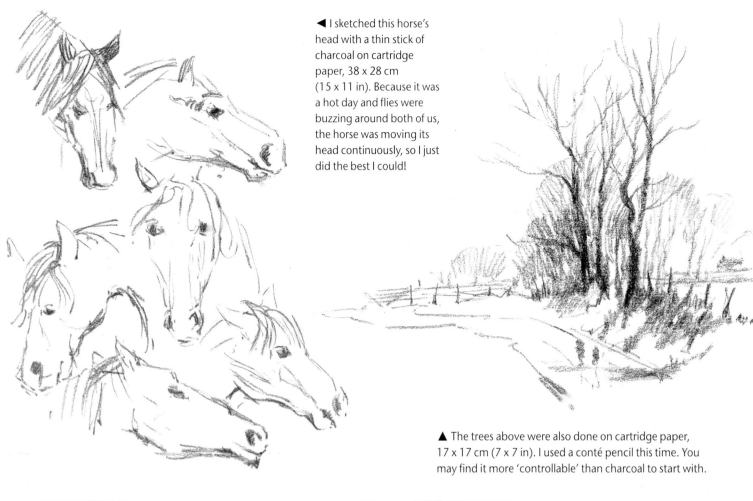

◀ I sketched this horse's head with a thin stick of charcoal on cartridge paper, 38 x 28 cm (15 x 11 in). Because it was a hot day and flies were buzzing around both of us, the horse was moving its head continuously, so I just did the best I could!

▲ The trees above were also done on cartridge paper, 17 x 17 cm (7 x 7 in). I used a conté pencil this time. You may find it more 'controllable' than charcoal to start with.

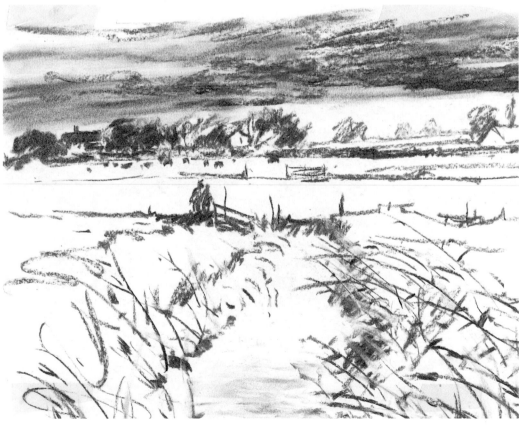

◀ I did this charcoal sketch in Norfolk on cartridge paper, 9 x 17 cm (3½ x 7 in). Notice how I have used my finger to smudge the sky behind the farm.

Exercises in Black and White

Now that you have experimented with black and white sketching materials, we can try some very simple exercises. I have done these in stages to show you how I work.

The first two exercises will help you develop a broad pencil treatment. Use your 3B pencil and hold it in the 'flat' drawing position (see page 20) to give you broad shading for the tonal work.

Start the exercise below by drawing in the line of the field, then put in the buildings (the centre of interest), and follow my stages. Then try the next exercise. Don't labour your pencil work – make your pencil work freely, trying for light against dark (strong contrast) with shading. Then try the last sketch.

You can try any of these exercises using other black and white mediums and this will help you to see which subject suits which medium. For instance, it would be difficult to get the atmosphere in the second exercise if you used a fine nib pen. The sky would be scratchy and difficult to make very black, but it would work well with charcoal.

These exercises should be useful. They will have made you copy something, which will help you to observe nature when you are out sketching. The more you sketch, the more confidence you will have so, whenever you have ten minutes to spare – *sketch*!

▼ I did this exercise on layout paper 15 x 15 cm (6 x 6 in) with a 3B pencil. Use your pencil in a 'flat' drawing position for the shaded areas. Although this is a very simple sketch, and worked without detail, the strong contrast between dark and light areas makes it work.

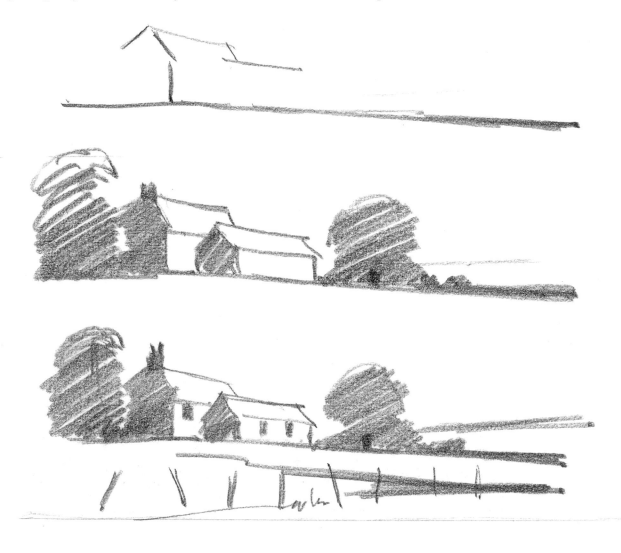

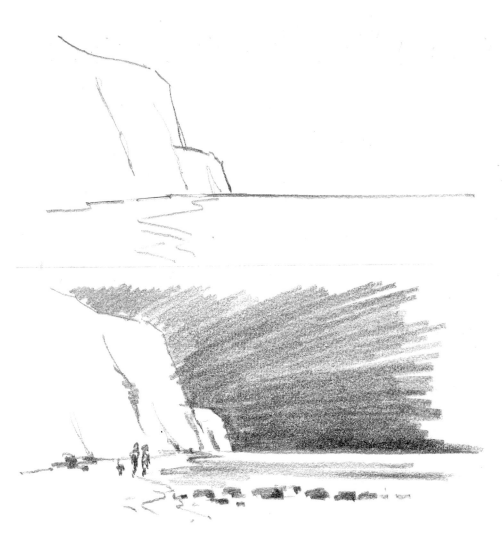

◄ This is another simple sketch to help you with shading. I did it on layout paper, 15 x 15 cm (6 x 6 in) using a 3B pencil. The shading of the dark sky is important. Again, hold your pencil in the 'flat' drawing position to do this. Notice how the angle of the shading changes as it nears the horizon and the shading becomes darker. I did this to add drama to the scene.

► This small sketch was done on layout paper, 9 x 12.5 cm (3½ x 5 in) with a 2B pencil. Follow the stages carefully. Of course, if I were to do a similar sketch of this house again from the same spot, on a different day, I might not start it in exactly the same way! That is the nature of sketching – as you gain experience, you will find that your feeling for each subject will dictate how you tackle it on the day.

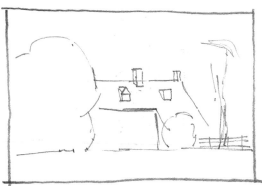

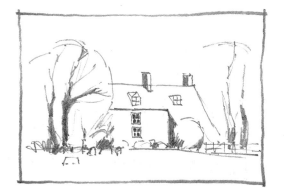

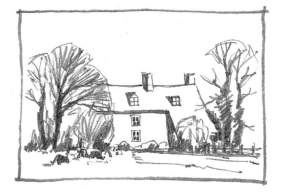

Working in Watercolour

Over the next few pages, I hope to take some of the mystery out of using watercolour. If you would like more guidance, other books in this series cover this medium in great detail, including my books *Learn to Paint Watercolours* and *Learn to Paint Outdoors in Watercolour*.

But first let us look at colour. It can make us happy, it can give the effect of cold, warmth, dark or light, and yet all the colours that we paint with are made up from only three: red, yellow and blue. These are called the 'primary' colours. I have listed the colours I use below, in order of importance to me.

Mixing colours

The next stage is to learn how to mix colours. On the next page you will see that I have mixed primary colours to make other colours. In watercolour painting you use more water and less paint to make your colours lighter. To make them darker use more paint and less water. I don't use black, only because I was taught not to, because it is a 'dead' colour. If you *mix* a black it is much more alive than any ready-made black.

Watercolour is a good medium to learn to paint with. Firstly, whether we were artistic or

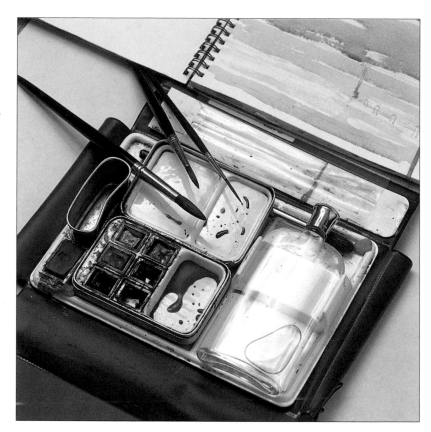

Always carry your sketchbook in a plastic bag when you are working outside. I once ruined all my watercolour sketches by dropping my unprotected sketchbook in a puddle!

My colours

French Ultramarine, Crimson Alizarin, Yellow Ochre, Hooker's Green No. 1, Cadmium Yellow Pale, Cadmium Red and Coeruleum. I use the first four colours for about 80% of my painting. I also, very occasionally, use Burnt Umber and Payne's Grey.

▲ My basic watercolour sketching kit is my Watercolour Travelling Studio, which I designed many years ago for easy working outdoors (*see left*). This contains a paintbox with six colours, a water bottle, water container, brush, pencil and a 13 x 28 cm (5 x 7 in) sketchpad. Lightweight and waterproof, it has a carrying strap which also supports it around your neck when you are standing to work. I rest my A4 or A3 sketchpad on it when working larger. My brushes are Nos. 10 and 6 round sable and a Dalon Series D99 'Rigger' No. 2.

not, most of us were taught to paint with water-based paints at school or even before, usually with poster paint (in jars) or powder paint (in tins, which had to be mixed with water). So a beginner to painting, at whatever his or her age, will not not feel totally alien to watercolour paints, because at some time he or she will have come in contact with them.

Secondly, watercolour is a very convenient medium to use indoors to practise with. Getting out a box of watercolour paints and working in a corner of a room is relatively easy, and there is no smell.

Mixing colours is fun, so have a go and see what you get. The more difficult colours to mix are the subtler ones, and these will come with practice and observation.

Use the predominant colour first

Always start your mix with the predominant colour. If you are mixing a 'yellowy' orange, begin with yellow and add a little red. To mix a 'reddy' brown, you should start with red, then add a little yellow, and then a little blue. I have listed my colours for mixing in this way throughout the book.

Keep things simple

When you first go outside sketching with watercolour, go for broad areas, using colours that are simple to mix. Time and experience will extend your colour range.

When you are out in the country, look at the distant hills, covering up the foreground fields with your hands. Then look at the foreground fields. The colour in the distance is blue compared to the green of the foreground field. In general, the distance is bluish (cooler), and the foreground is warmer and has more real colour.

Look for these colour changes and observe them in your sketches and you will find that the background stays in the distance, and the foreground in front. Your sketches will then have meaning and come to life.

In general, to make your colours cooler (for distance), add blue, and to make them warmer (for foreground), add red.

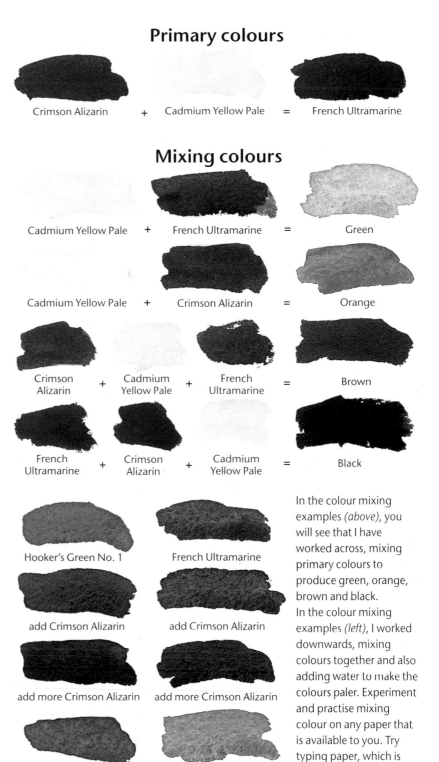

Primary colours

Crimson Alizarin + Cadmium Yellow Pale = French Ultramarine

Mixing colours

Cadmium Yellow Pale + French Ultramarine = Green

Cadmium Yellow Pale + Crimson Alizarin = Orange

Crimson Alizarin + Cadmium Yellow Pale + French Ultramarine = Brown

French Ultramarine + Crimson Alizarin + Cadmium Yellow Pale = Black

Hooker's Green No. 1 — French Ultramarine

add Crimson Alizarin — add Crimson Alizarin

add more Crimson Alizarin — add more Crimson Alizarin

add water — add water

add French Ultramarine — add more water

add water — add French Ultramarine

In the colour mixing examples (above), you will see that I have worked across, mixing primary colours to produce green, orange, brown and black.
In the colour mixing examples (left), I worked downwards, mixing colours together and also adding water to make the colours paler. Experiment and practise mixing colour on any paper that is available to you. Try typing paper, which is inexpensive – then you won't be worried about starting over and over again. Begin by mixing your colours just from the three primaries, because this will help you to understand colour mixing more easily. Good luck and have fun!

Exercises in Colour

Now that you have practised colour mixing, you will be ready to try some simple exercises. Don't let the exercises on these two pages worry you because they have shape and form, while you may only have experimented with coloured 'doodles' so far.

Simplifying objects

If you look at the small rowing boat on the opposite page, the first stage is really just a shapeless doodle of two colours and the second stage only gets its boat shape by adding one darker tone in the correct places. This comes from observation of your subject, but you can see how to simplify objects and still make them appear three-dimensional.

Take this a little further and look at the wheelbarrow below the rowing boat. As you gain confidence you will find that you can put the second tone in (the shadow side of the wheelbarrow) as you paint in the first stage. In other words, you would paint in the light area on two sides and then paint in the other two sides with a darker tone. In this way, you miss out a stage. When you are painting complicated subjects you will find that this happens throughout the picture.

Discovering short cuts

Concentrate on working simply at first. This is especially important when you are out sketching. If you find short cuts that enable you to work better, by all means use them. Painting is a very personal thing and, with experience, all artists develop their own special methods and techniques.

I did the sketches on the opposite page for you to copy on cartridge paper. I hope you enjoy doing them, as well as the step-by-step exercise on this page.

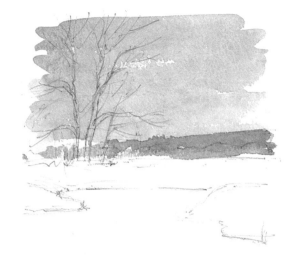

◀ I started by drawing this sketch with a 2B pencil on Bockingford paper, 15 x 15 cm (6 x 6 in). I used my No. 6 brush for the whole sketch, first painting in the sky using French Ultramarine and Crimson Alizarin. When this was dry, I used the same colours, but stronger, to paint in the distant hills. Notice how blue they are.

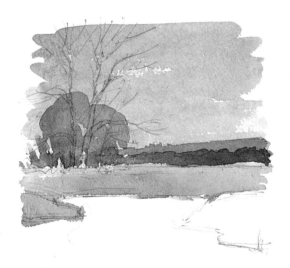

◀ When this was dry, I painted the distant trees with a mix of French Ultramarine, Crimson Alizarin and a little Yellow Ochre. I used a mix of Crimson Alizarin and Yellow Ochre for the autumnal foliage behind the large trees, then a varying mix of Cadmium Yellow Pale, Crimson Alizarin and a touch of Hooker's Green No. 1 for the fields.

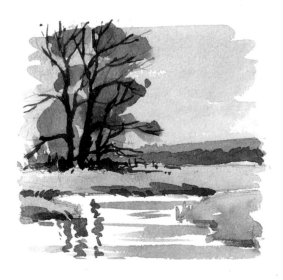

◀ In the final stage, I painted in the large tree and the hedgerow and, when this was dry, painted autumn leaves over the branches. The same colour was used for the shadows on the river bank. Then, with the sky colour, I painted horizontal brush strokes to represent water. Finally, when the water was dry, I put in the reflections of the trees.

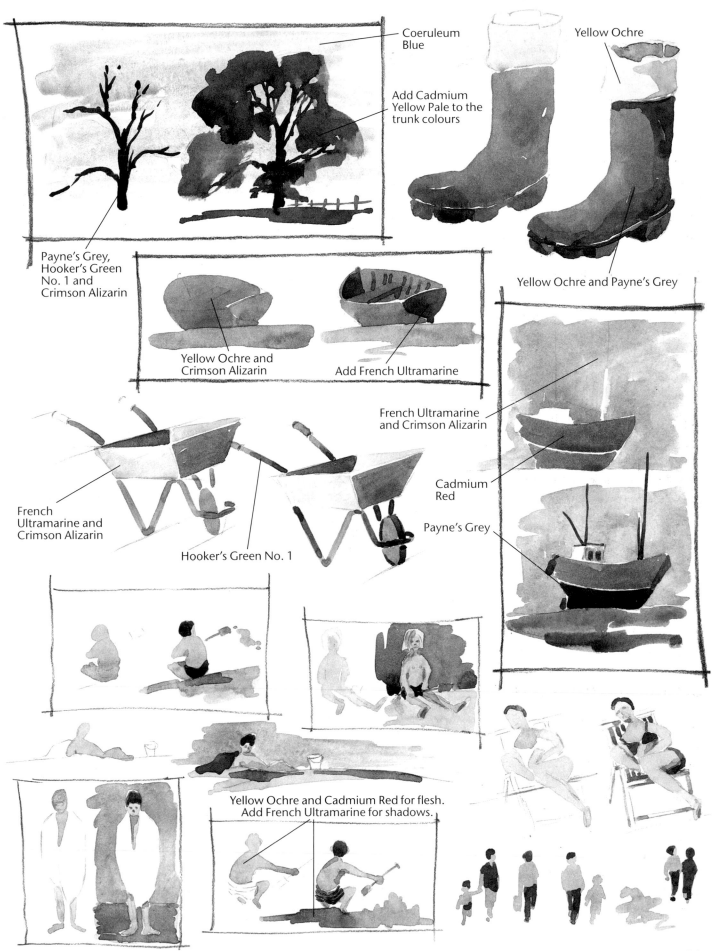

Coeruleum Blue

Add Cadmium Yellow Pale to the trunk colours

Yellow Ochre

Payne's Grey, Hooker's Green No. 1 and Crimson Alizarin

Yellow Ochre and Payne's Grey

Yellow Ochre and Crimson Alizarin

Add French Ultramarine

French Ultramarine and Crimson Alizarin

French Ultramarine and Crimson Alizarin

Hooker's Green No. 1

Cadmium Red

Payne's Grey

Yellow Ochre and Cadmium Red for flesh. Add French Ultramarine for shadows.

Further exercises

Here are two more simple exercises for you to try. Look at the four stages of my sketch of Sarlat in the Dordogne, France *(below)* and follow them carefully. This sketch was drawn with a 2B pencil on Bockingford watercolour paper, 17 x 15 cm (7 x 6 in). The shadow colour, for the people and inside the archway, is very important to the sketch and was mixed from French Ultramarine, Crimson Alizarin and a touch of Yellow Ochre.

▲ First stage

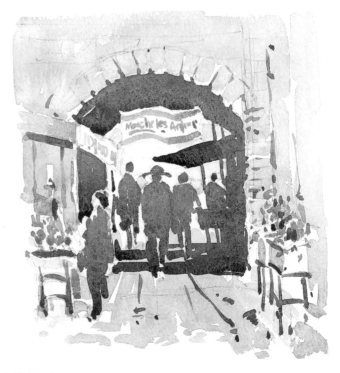

▲ Second stage

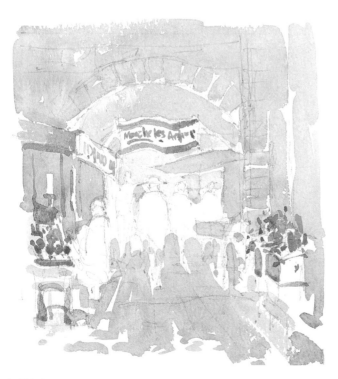

▲ Third stage

▲ Finished stage

▶ I used cartridge paper measuring 15 x 28 cm (6 x 11 in) for this watercolour sketch of Norfolk countryside and started by drawing in the sketch with my 2B pencil. Then I shaded in, using my pencil in the 'long' drawing position (see page 20).

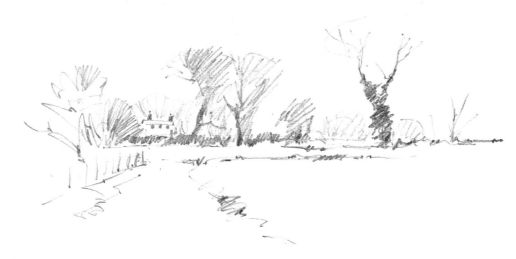

▲ First stage

▶ I painted in the sky with my No. 10 brush and a mix of French Ultramarine and a little Crimson Alizarin. I left the house as unpainted white paper. Then I painted the grass with a mix of Cadmium Yellow Pale and Hooker's Green No. 1 and then used Yellow Ochre, Crimson Alizarin and a little French Ultramarine to put in the path.

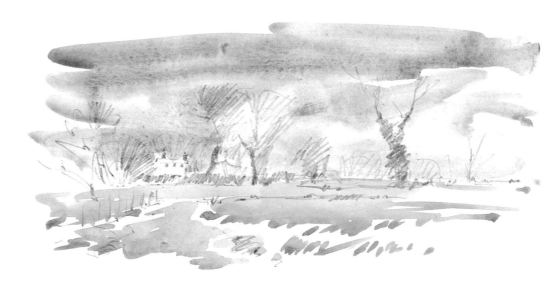

▲ Second stage

▶ I made the sky colour darker by adding a little Yellow Ochre and used this to paint in the distant trees. I still left the house as unpainted paper. Then, using the grass colours, but darker, I painted over the trees. Finally, I painted some dark areas on the grass to give form and shape.

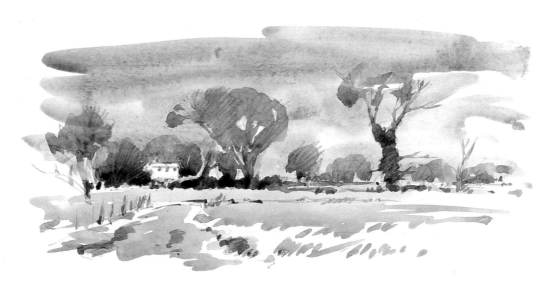

▲ Finished stage

33

Measuring Outdoors

I consider this to be the most important section in the book. Let us assume you are ready to start sketching. You must first observe the scene in front of you carefully and become familiar with what you are about to draw. This could take up to 15 minutes depending on how complicated the subject is, and how much time you have to sketch, but believe me, it will be time well spent.

Measuring your subject

At this point you might understand everything you see, but how do you work out the relative sizes and positions of objects in your scene, and transpose them accurately on to your paper?

This is a very important skill to acquire. Although to start with you may find it tedious, or perhaps a little mechanical, you must persevere. It will soon become second nature and as much a part of sketching as putting pencil to paper. The principle is simple. Hold your pencil at arm's length, vertically for vertical measuring and horizontally for horizontal measuring, with your thumb along the near edge as your 'measuring' marker. By always keeping your arm at the same distance from your eye during measuring, the comparative distances will be consistent.

Finding a key measure

The object of the exercise is to measure the subject and apply it to your paper. Obviously, you do not use the same length to measure your actual subject as you do for the subject on your sketch. You are simply trying to get the correct proportions, so let me take you through the example at the top of the next page.

Suppose the first sketch, **a**, is a real row of houses. Draw a part of your sketch, say house no. 3, on your paper as in **b**. You now need to get houses nos. 1 to 7 on your sketch as they

◄ Using a pencil for vertical measuring.

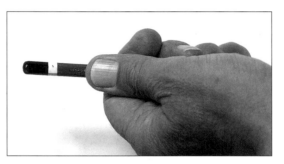

◄ Using a pencil for horizontal measuring.

appear in reality. Hold up your pencil to measure house no. 3 and, as you move your hand along, measure how many widths of house no. 3 will go into the length of the seven houses (nine). Check your sketch, **b**, and using your pencil as a scale, measure whether the width of the house no. 3 you have drawn can be drawn along your paper nine times. In **b** it can be drawn only about five times. So draw a smaller house on the same sketch, **c**, and by simple trial and error you will come to the size of house that will fit on to your paper nine times.

Now hold up the pencil to the real scene to measure how many widths of house no. 3 can be divided into houses nos. 1 and 2. You will find that they are all the same size. Therefore, on your paper, you can measure three houses from left to right, the third being no. 3, which is your key measure, **d**. Looking up at your subject again, measure how many widths of house no. 3 can be divided into house no. 4 (two). On your sketch, using your pencil as a

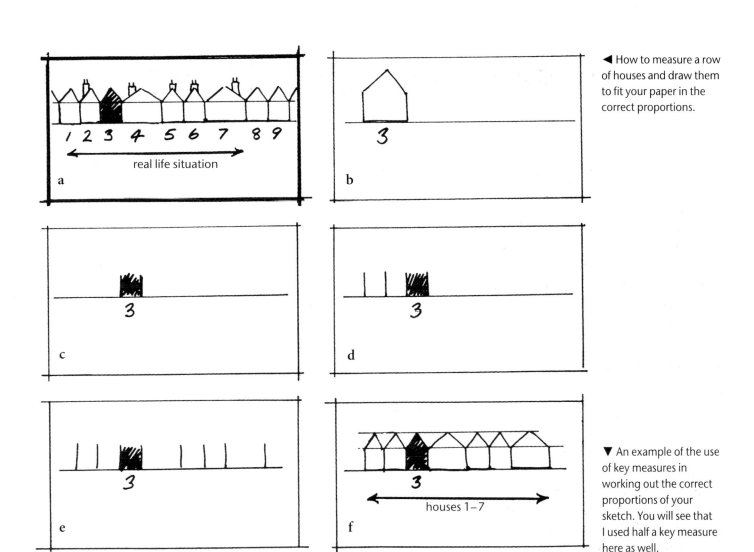

a | real life situation

b

c

d

e

f

houses 1–7

◄ How to measure a row of houses and draw them to fit your paper in the correct proportions.

▼ An example of the use of key measures in working out the correct proportions of your sketch. You will see that I used half a key measure here as well.

ruler and your thumb as a marker, measure a distance twice as long as, and to the right of, house no. 3. You thus have the correct measurement for house no. 4. Continue in this way until you have drawn the row of houses from 1 to 7. They will fit your paper exactly, **e**.

Now check the height of the houses. Measure the width of house no. 3 and turn your pencil vertically, with your thumb still in position, to see how many widths of the house will divide into its height. You will find that it fits exactly once, up to the bottom of the eaves. On your sketch, use your no. 3 house measure and mark the height of the houses, as in **f**. Then check the height of the roofs, and so on.

If you take time to do this, you can put as much detail into the houses as you want, knowing that your drawing will end up on your sketchpad (not falling off it!) and it will be proportionally correct.

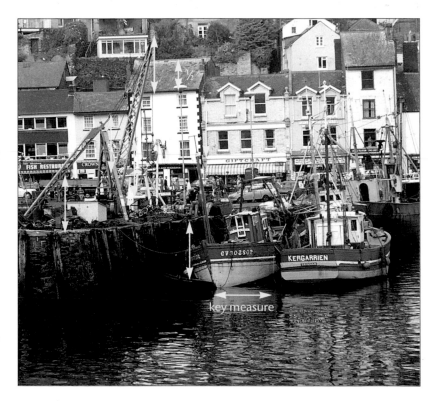

key measure

A Step-by-Step Sketch

Now that you know how to start a sketch, let's go through the development of a simple one to exactly see how it works. At this stage you have observed your subject, and are sitting or standing comfortably, you know the type of sketch you are going to do, you can measure, and you have decided what your centre of interest is. I shall take you through the stages but look at the finished stage first, to familiarize yourself with the picture.

First stage
The first line to draw is the line of the main field. Position this near the centre of the page then you can add more foreground or sky later. Next position the farm (centre of interest). I wanted this picture to be long and thin, as it was the long line of the farm buildings which inspired me to draw it.

Second stage
Draw the farm buildings in.

Third stage
Complete the buildings. Emphasize the lower part of them so they don't appear to float away. Draw in the hills and the new field.

Fourth stage
Now draw the tree. You will see that I have drawn two more lines across, one above the buildings, and one below. This gives you the long shape of the picture dominated by buildings.

Fifth stage
It is a good idea to add more information if you have the time and this I did in stage 5. The path is extended and the gate and fence have been drawn in. This could make a 'happy', designed picture with the path leading you to the centre of interest.

Finished stage
In the finished stage, I have shown a different picture shape by cutting the sketch off just above the tree. So this one sketch can make three different pictures shapes – stages 4, 5 and 6.

I did this step-by-step sketch with my 2B pencil on tracing paper. The idea was taken from nature, but the sequence of stages was done in my studio to explain, very simply, the progress of a sketch.

▶ So that you can follow the stages, I have developed a simple sketch through from start to finish, and shown how the same scene can be used in three different ways.

▶ **Devon Farm**
2B pencil and watercolour
15 x 25 cm (6 x 10 in)
Try masking this sketch to see how many different pictures you can make.

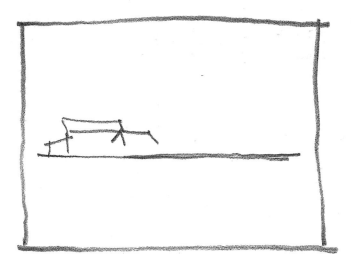

▲ First stage

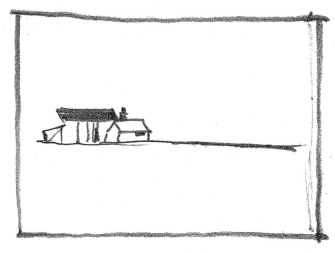

▲ Second stage

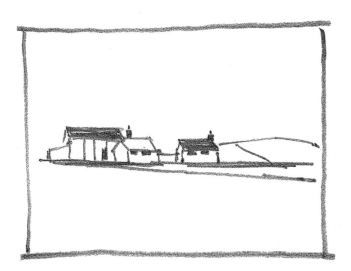

▲ Third stage

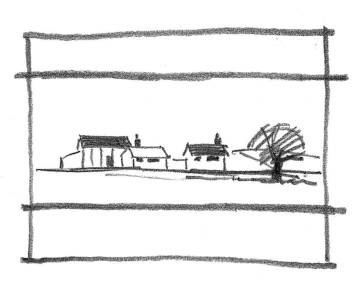

▲ Fourth stage

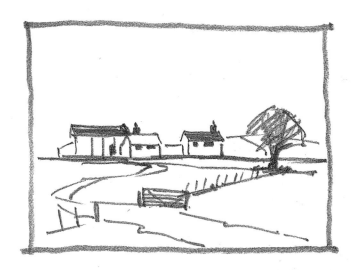

▲ Fifth stage

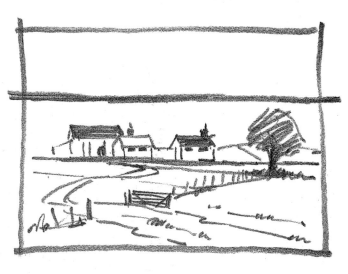

▲ Finished stage

Sketching Movement

When you are learning to sketch you must think that there are enough complications sketching something stationary, without trying something that moves! As usual you must observe and understand your subject. If anything, this is even more important for capturing movement. Measuring is also important, but it can be very frustrating; particularly when, for instance, you measure the length of an animal's head to see how many times it goes into the body length, and then it completely changes its position!

When I am asked if I have a magic formula for drawing a moving subject, sadly the answer is no. However, there are ways of approaching your subject that will enable you to master this part of sketching.

Practice and patience

The most important priorities after observation and understanding your subject are practice and patience. Let us assume you are sketching heavy horses. You should look at them and study their most outstanding features. You will find they stand still for minutes at a time. Look for the obvious key

Photographs are a great help when you are sketching moving subjects like animals. Take some to compare with your sketches when you get back home.

▲ **Nigel, the photographer**
2B pencil on cartridge paper
10 x 10 cm (4 x 4 in)

▶ **Students on one of my courses**
2B pencil on cartridge paper
15 x 14 cm (6 x 5½ in)

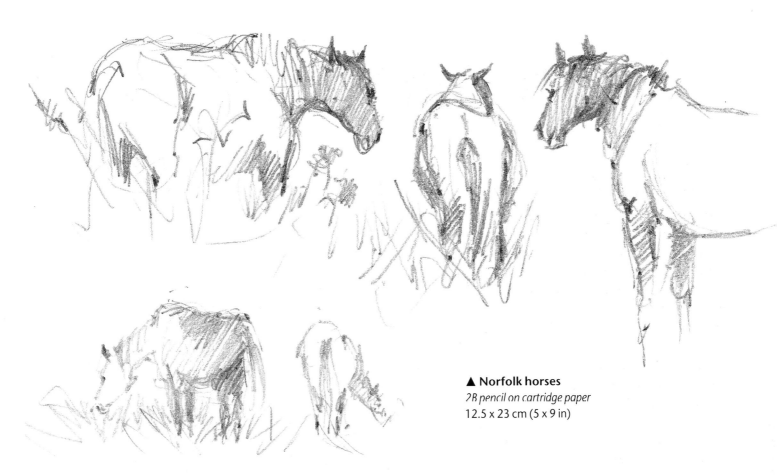

▲ **Norfolk horses**
2B pencil on cartridge paper
12.5 x 23 cm (5 x 9 in)

positions of their anatomy, such as where a foreleg starts, how long it is compared to the depth of body, and so on. In this way, you are measuring and positioning through observation, before you start to draw.

Learn with your sketches

Your observation could last anything from half an hour to an hour. It's up to you, but don't 'draw with your eyes' for too long or you will find it much more difficult to actually start sketching. When you do begin, carry on at your own speed, observing carefully, and if your subject moves, stop and start another. You may find that your subject regains its original position, or that another horse takes up the same attitude so you can carry on your sketch using a different model!

Never worry that you don't finish one horse completely. You are learning by observing and when you sketch as well, you are recording what you see. This combination of activities will quickly give you a good knowledge of your subject.

▼ **Elephants at Paignton Zoo, Devon**
2B pencil on cartridge paper
23 x 30 cm (9 x 12 in)

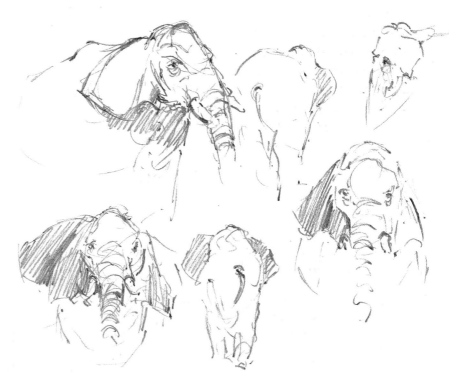

Time well spent

Naturally the more you do, the more your sketches will flow. If I were to sketch horses for two hours, I would start by spending about half an hour wandering around looking and observing. The next 10 minutes I would spend sketching. The chances are it would not be very good, but I would be relaxing and getting the 'feel' of the subject. Then, for the next hour, I would work very hard, totally involved in what I was drawing, and that time would be spent gathering useful information. After that, my concentration would start to lapse and the results of the last ten minutes would resemble those of the first ten!

Watching movement on television

One way of training your eye to retain a moving image long enough to draw its shape is to sketch movement on your television screen. This is difficult, but can be done. You won't finish anything and your sketchbook may seem to be filled with unsatisfactory work but these sketches are a means to an end and will train your brain to work and observe faster than normal. You will learn to look for and see things that hadn't occurred to you before, and you will need to see in seconds how to simplify shape and form.

Finally, if you aren't successful in sketching movement, don't worry. Stick to the vast range of stationary subjects – just so long as you enjoy yourself!

When sketching movement, remember my rules – be patient, observe, look for simple shapes and form, work your speed up, and practise, practise and practise!

▲ This sketch was done on cartridge paper, 25 x 38 cm (10 x 15 in) using my Watercolour Travelling Studio. I did it at an art materials show and my biggest problem was the people who kept blocking my view! But patience prevailed and I was happy with the finished sketch.

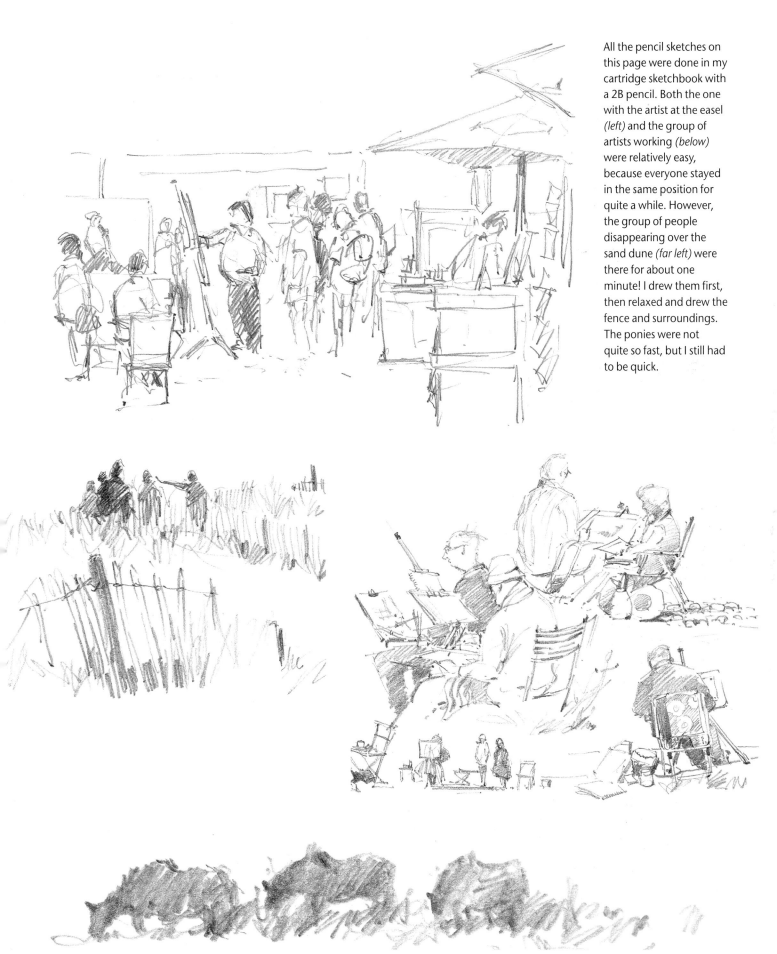

All the pencil sketches on this page were done in my cartridge sketchbook with a 2B pencil. Both the one with the artist at the easel *(left)* and the group of artists working *(below)* were relatively easy, because everyone stayed in the same position for quite a while. However, the group of people disappearing over the sand dune *(far left)* were there for about one minute! I drew them first, then relaxed and drew the fence and surroundings. The ponies were not quite so fast, but I still had to be quick.

When is a Sketch Finished?

You should stop working on a sketch when you have got the information that you wanted, or when you feel you have been drawing long enough – whether it's because you're tired, hungry, cold or just bored with the subject. Remember, you are sketching to enjoy yourself.

On one occasion I had been sketching for most of the day. I was feeling very tired, and ready to go home, when I saw a group of boats that caught my eye. I decided to do a 'quick' sketch – the last one. (Incidentally there is no such thing as a quick sketch, unless it tells a story.) The result *(shown right)* was disastrous. I still can't make sense of it, even now. It went wrong because I had tried to work fast. There is nothing wrong with that, but my brain was tired and didn't observe so I drew it without 'seeing'. Unless you observe, your drawn lines become meaningless.

▲ This sketch turned out to be a total disaster!

▼ I did this in my A4 cartridge sketchbook as a demonstration for students in Jersey and, as the helicopter came over, I was persuaded to draw it in. I had about 8 seconds to do this!

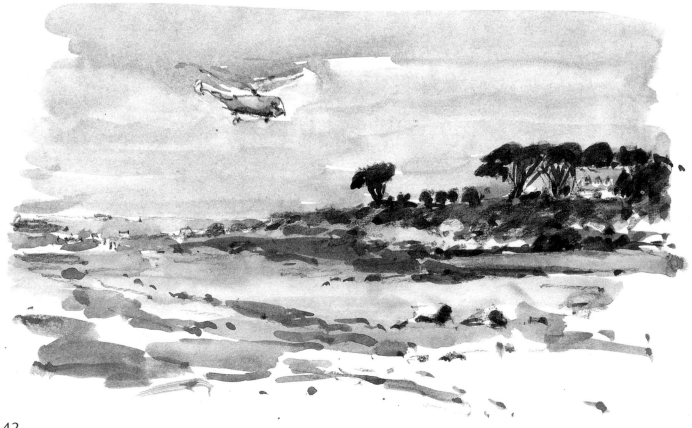

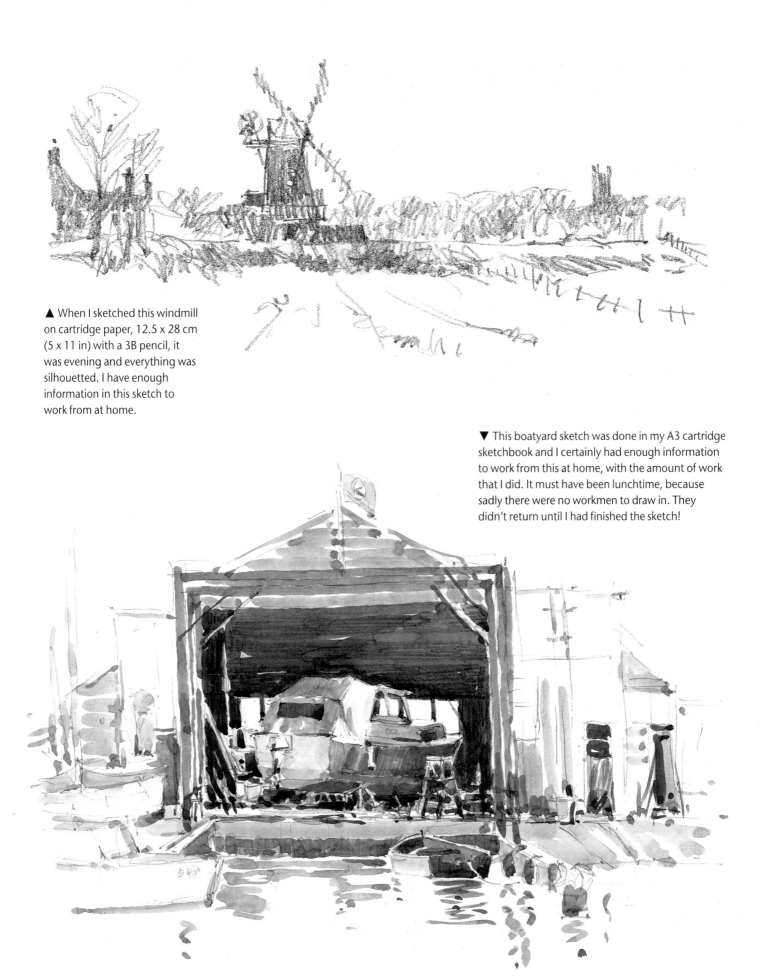

▲ When I sketched this windmill on cartridge paper, 12.5 x 28 cm (5 x 11 in) with a 3B pencil, it was evening and everything was silhouetted. I have enough information in this sketch to work from at home.

▼ This boatyard sketch was done in my A3 cartridge sketchbook and I certainly had enough information to work from this at home, with the amount of work that I did. It must have been lunchtime, because sadly there were no workmen to draw in. They didn't return until I had finished the sketch!

Some Questions Answered

I decided to present three of my sketches to a group of artists and students so they could question me about them. I haven't included some questions that have been covered in other parts of the book.

Why did you sketch the digger?

I was out sketching one cold February and, as I walked up the road, I saw the mechanical digger. Half of the road had disappeared and there was a massive crater where it had been! I had never seen anything like it and sat down in the middle of the 'road' to record it. It was a typical enjoyment sketch – so unexpected and exciting – and it is now on paper for ever.

What made you position the tower of Windsor Castle in the middle of the picture?

I started with the centre of interest – the tower – and worked on either side of it. (If you are going to paint from the sketch at home, you can decide where you want your centre of interest then.) As it happens I like the composition of the sketch, because the tower and the flag give it a pyramid shape, making the castle look solidly placed on the ground.

What inspired you to do the colour sketch of Sutton Staithe?

The sunlight coming through the trees combined with the warm colour of the building in the background totally inspired me – I just had to sketch it!

How do you scale up a sketch to do a larger picture?

I've drawn a little diagram to show you. Use a ruler and draw a line diagonally across the page from one corner to another. Wherever you draw a line parallel with the top of the sketch page to meet your diagonal line, drop a

perpendicular line down, parallel to the side of your sketch page and that area will be exactly in proportion to your sketch.

How important is sketching?

It teaches you to observe. It takes you out of doors to see and feel nature and to record. It is the life blood of your inspiration. If you can go out sketching – then you should!

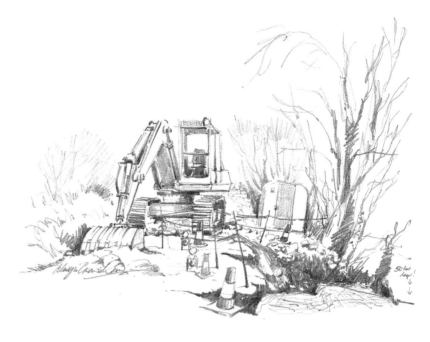

▲ The mechanical digger was drawn in my A4 cartridge paper sketchbook with 2B pencil. It is one of the most unusual subjects I have ever sketched!

▼ How to scale your sketch up or down to any size you want while still retaining the correct proportions of your original sketch in your finished painting.

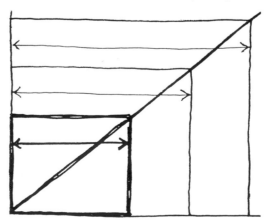

▶ Sutton Staithe, Norfolk
I did this in my A3 sketchbook. I was simply inspired, and what better motive for painting! I enjoyed every minute of this sketch.

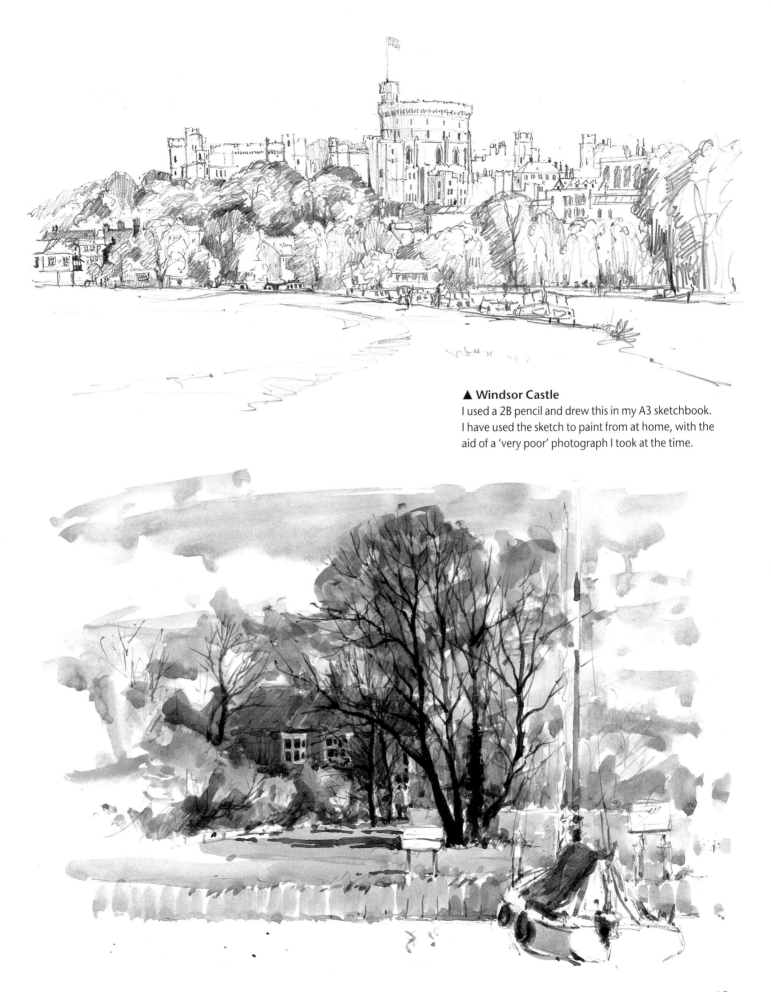

▲ Windsor Castle
I used a 2B pencil and drew this in my A3 sketchbook.
I have used the sketch to paint from at home, with the
aid of a 'very poor' photograph I took at the time.

Country Village

I chose a very free style of sketch for my first demonstration, because it didn't require a lot of careful drawing. In fact, apart from the church tower, all the lines are drawn with great freedom which helps to give life and movement to any pencil sketch. This type of sketch is always very enjoyable to do.

First Stage

For each of the following demonstrations, I sketched first outside on location, and then copied my sketch in the studio, stopping at each stage so that it could be photographed. This step-by-step method will enable you to follow the main structure and progression of each sketch, and to see how it developed from the first to the finished stage.

In this sketch of Dedham, Essex, I positioned the church tower first, then put in the houses. The chimneys are important because they add interest and help to capture the character of the houses in the village. Then I drew a line to position the two fields and positioned the two main trees.

Second Stage

Next I drew in the main tree on the left and shaded the trunk and branches. Don't be too fussy when you do this, and be very careful not to fiddle!

I suggested the background trees to the left with my pencil in the 'long' drawing position (see page 20). Then I worked to the right, shading in some of the roofs and windows of the houses, and drawing in the right-hand trees. At this stage, make sure you have put enough shape and form into your houses and that the chimneys, gable ends and windows are easily recognisable features. This is important to make the middle distance understandable.

3B pencil

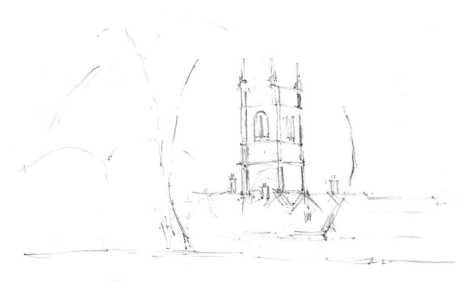

▲ First stage

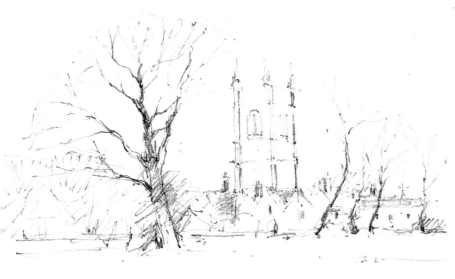

▲ Second stage

Finished Stage

At this stage I put in more detail to give form to certain areas. I shaded in the windows on the church, drew in the line of the river bank and the small bush on the left, and suggested the riverside plants. Finally, I added more detail and shading to the big tree and the hedgerow.

If you look at my sketch very carefully you can see how I let my pencil 'roam around', leaving apparently unrelated marks on the paper. I approached the sketch in a very relaxed manner and I think this shows in the sketch. If you feel far from relaxed when you first start sketching, don't worry. The tension will go as you gain confidence. Just remember that the key to confidence-building is lots and lots of practice!

▼ **Country Village**
3B pencil on cartridge paper
23 x 35 cm (9 x 14 in)

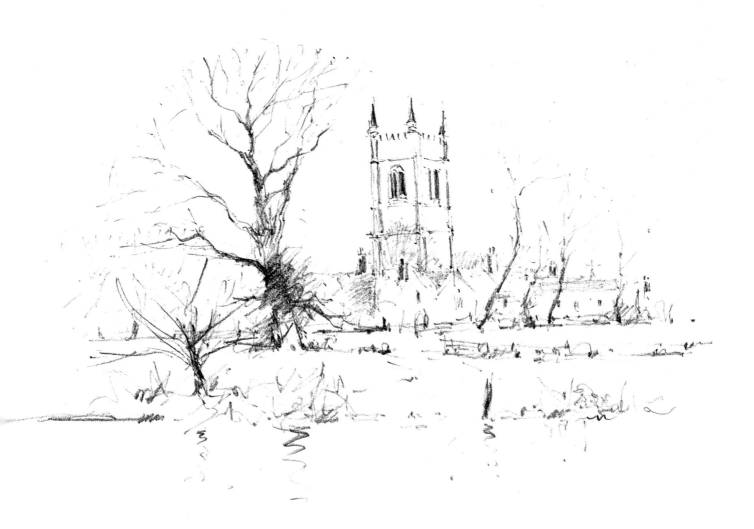

Low Tide, Topsham

I find this type of scene ideal for pen work. There aren't many large, dark areas to be shaded, there is plenty of activity to suggest and if you felt like it, you could put a lot of simple detail into the wet mud and stones in the foreground.

First Stage

If you don't feel confident enough to start a sketch in pen, you can always position and draw in the main features with a pencil first.

I drew in the main house first, then worked to the right, drawing in the houses, the harbour wall and the boat. It was important to establish this area because it is the centre of interest. Finally I positioned the tree.

When using a pen you do have to be more accurate with your lines than with pencil, but don't be put off by this. If you have to reposition a few lines it won't spoil your sketch. In most cases it can even make it look better! Just make the final, correct line a little heavier.

Second Stage

I put more detail into the main house now, adding shadows under the eves and shutters. Notice how the shutters on the ground floor windows were drawn with 'free' horizontal pen strokes which I allowed to join up in places. Then I drew the tree with the two figures, and the shadow on the harbour wall.

Next I added more detail to the boats and the two people behind. When I shaded and drew in the bottom of the harbour wall, I made it uneven and suggested some stones. When you do this, don't be tempted to carry on drawing endless stones. It is an easy trap to fall into because they are so easy to draw!

Marker pen

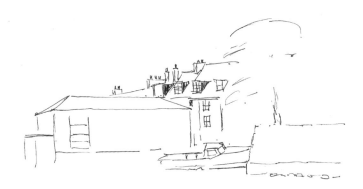

▲ First stage

Finished Stage

I now gave my attention to the left-hand side of the sketch. I started by drawing the buildings in, the boat on the left and small yacht behind it. It was important not to put too much detail into this area as this would detract from the centre of interest on the right-hand side. I added shading as I worked.

I drew broken horizontal lines on the mud area to give the illusion of wetness, and also put in a suggestion of stones and some reflections. The most important reflections are the one from the yacht mast and the bottom of the harbour wall.

If you use a waterproof ink pen, you can always paint over your pen drawing with watercolour to make a pen and wash sketch.

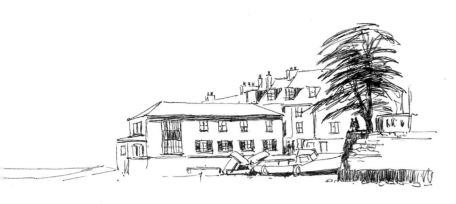

▲ Second stage

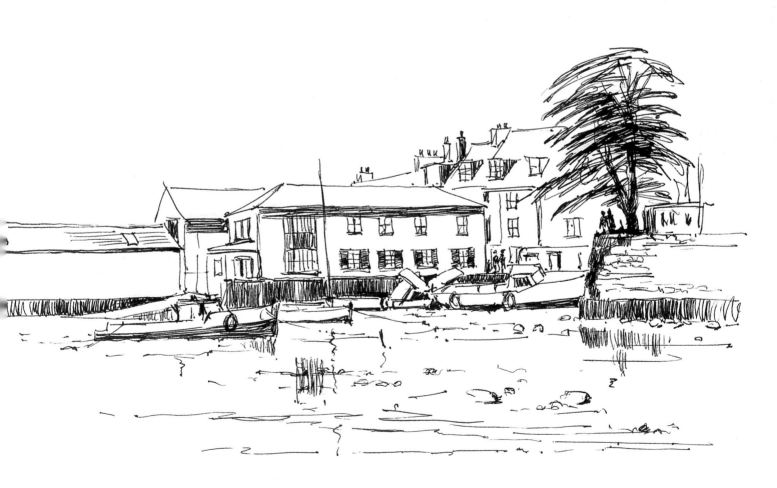

▼ **Low Tide, Topsham**
Pen on layout paper
23 x 35 cm (9 x 14 in)

Winter Hedgerow

I find charcoal a wonderful medium for drawing trees and have used a hedgerow for this exercise to whet your appetite for sketching this type of scene. Next time you are outside in the winter, observe all the different shapes and sizes of trees you get in a typical hedgerow – I know you will be surprised!

First Stage

I used a 2B pencil to draw in the main shapes of the trees and the hedgerow. Then I started in charcoal, working across from the left-hand side of the paper to the right. I did this so that I could rest my hand on the paper without smudging the work.

I drew the first tree but didn't bother with any of the small branches yet. Then I drew in the large tree on the right in the same way, and finally the small trees on the right.

I used a flat edge of the charcoal, holding the stick in a 'flat' pencil position to fill in large areas like the trunk. For the small thin branches I held the charcoal in a more upright position and drew with the edge of the stick.

Second Stage

This stage introduces you to one of the delights of charcoal – smudging! I started by rubbing my finger over the small right-hand trees to create the illusion of a mass of branches. If there isn't enough charcoal to make it look dark enough, you can always draw in some more branches and smudge over them again with your finger.

I darkened some branches to get back definition. Then I worked on the two main trees, adding more branches to form the overall shape of the tree. I worked up and outwards with my strokes because it is always essential to draw branches in the direction that the tree grows.

Charcoal

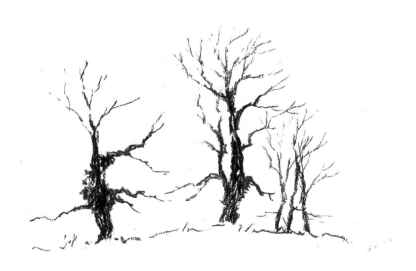

▲ First stage

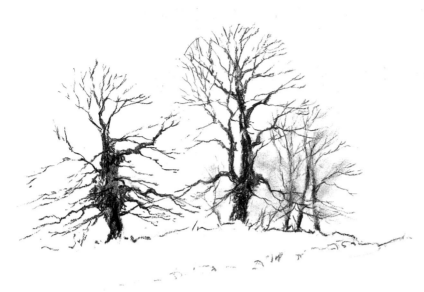

Finished Stage

Next I worked more dark areas into the right-hand trees with my finger. Then I drew over all the trees again, adding more small branches and darkening the trunks in places.

Then I sketched in a fence, added some hedgerow plants under the trees and drew in the path. Finally, I put some detail into the path and drew in the shadows that the trees cast across it using the flat edge of my charcoal.

▲ Second stage

▼ **Winter Hedgerow**
Charcoal on cartridge paper
12.5 x 25 cm (5 x 10 in)

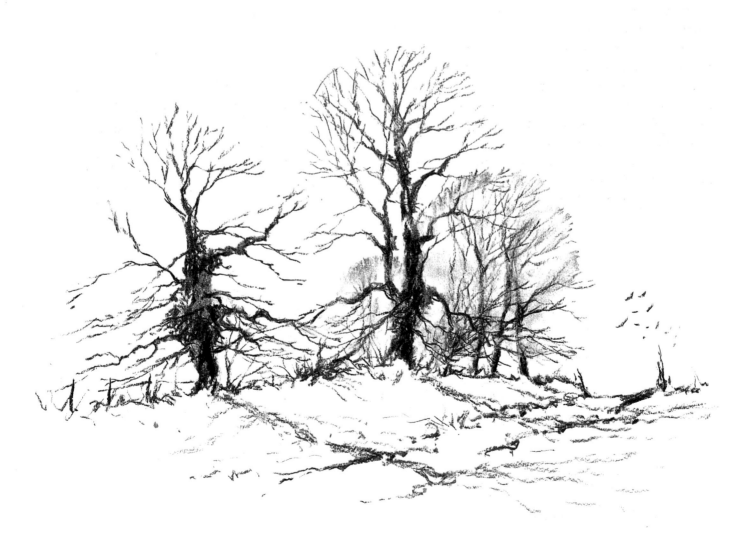

Crab Boats

I find this type of sketch very exciting but, with the boats and fishermen continually changing position and the wind blowing your sketchpad, you have to work fast! I was on the beach at Sheringham, Norfolk, when I sketched these crab boats coming in.

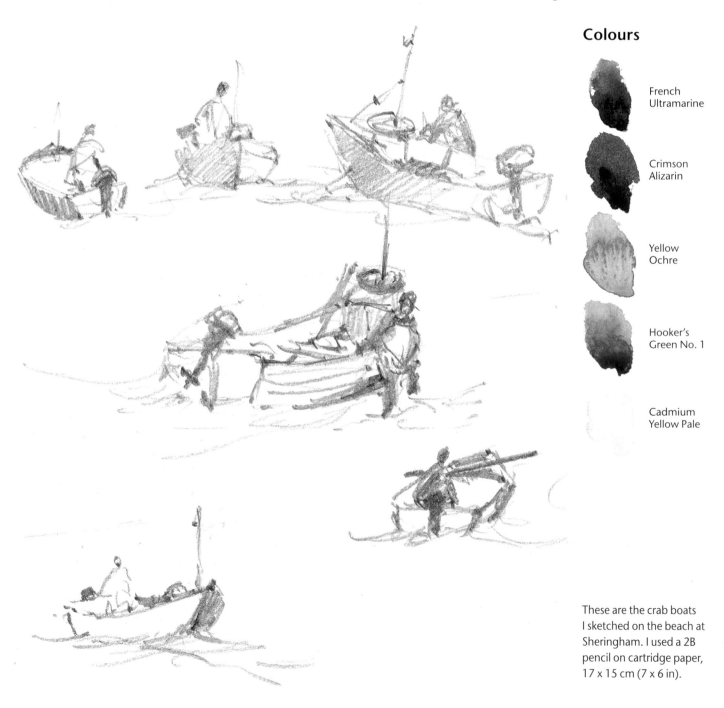

Colours

French Ultramarine

Crimson Alizarin

Yellow Ochre

Hooker's Green No. 1

Cadmium Yellow Pale

These are the crab boats I sketched on the beach at Sheringham. I used a 2B pencil on cartridge paper, 17 x 15 cm (7 x 6 in).

First Stage

My references for this sketch were the sketches I did on location (left) and a photograph which I took at the same time. I also had the benefit of valuable 'on the spot' experience.

I tried to recreate the feeling of my location sketches but also added colour. Of course, my studio sketch is a more controlled one than I could achieve sitting on a windy beach!

I started by drawing in the edge of the beach and then put in the main outline of the boat. I drew the two fishermen next and added detail and shading inside the boat. Finally, I drew the boat in the background waiting to come in, the post and the horizon line.

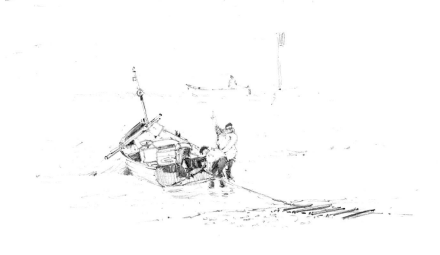

▲ First stage

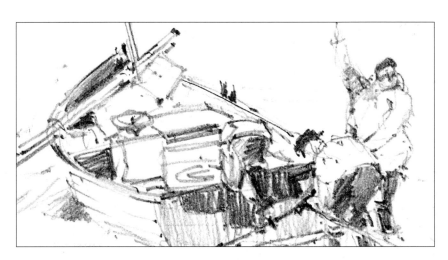

◀ Detail from first stage, reproduced actual size

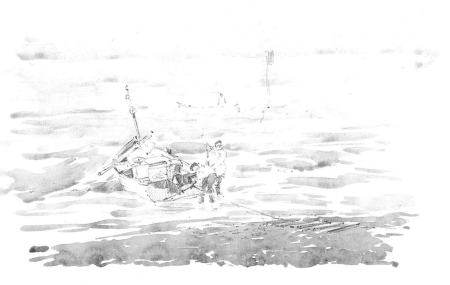

▲ Second stage

Second Stage

I painted the sky, working down into the sea with my No. 10 brush and a varying mix of French Ultramarine, Crimson Alizarin, Yellow Ochre and Hooker's Green No. 1 and plenty of water. I left lots of horizontal areas of white paper unpainted to show breaking waves and reflected light. I painted the beach with a stronger mix of Yellow Ochre, Crimson Alizarin and a little French Ultramarine.

In real life, the boat would probably have been pulled up onto the beach by the time you reached the painting stage. This is why it is important to get all your drawing, including any detail needed, done first. After that the boat would still be visible for colour reference and the sky and sea wouldn't have moved!

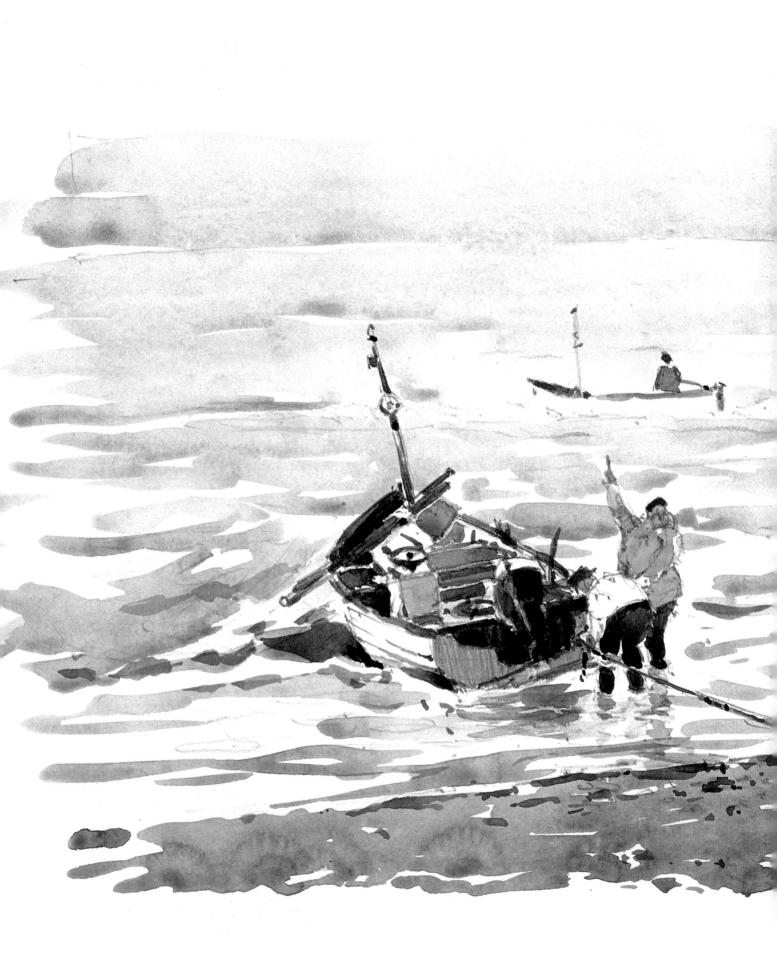

Finished Stage

I painted the detail inside the boat with my No. 6 brush, using French Ultramarine for the blue trim. Next I painted the dark shadow on the water to the left and the right of the boat and, using the same colour, painted the fisherman's trousers. I added detail to the beach to represent stones, and painted the ramp which the boats are pulled up on and the rope. Then, with Cadmium Yellow Pale and a touch of Crimson Alizarin, I painted the fisherman's yellow waterproofs.

Finally, I added a little colour to the waiting crab boat and put in any darks and detail that I felt helped the sketch.

◄ **Crab Boats, Sheringham**
2B pencil and watercolour on cartridge paper
20 x 30 cm (8 x 12 in)

Windy Day

This type of sketch works well as a drawing in its own right but if you have time when you are on location it can be fun to add watercolour. I like this way of sketching and do it a lot. This particular spring day was very fresh and blustery. Since I was standing when I did the original sketch, I had to work fast.

First Stage

I positioned the edge of the ploughed field first. Then I put in the right-hand end of the house. I worked to the left, drawing in the roof, chimney stacks and then the big tree, but didn't shade it in case I decided to move its position later – at this stage in a sketch, you can change your mind. I then drew in the small tree on the left and the telegraph pole. Next I drew the house and the trees on the right of the sketch and finally put in the ploughed field furrows.

Once you are happy with the positioning and drawing in your sketch, you can shade in different areas to get your tonal values. The amount of shading you put in on location is entirely up to you.

Second Stage

I used my No. 10 brush and a watery mix of French Ultramarine, Crimson Alizarin and Yellow Ochre for the sky, letting the paint run freely. Then I painted the roof with Cadmium Red and a touch of Cadmium Yellow Pale.

I suggested the distant trees to the left of the house with a mix of French Ultramarine, Crimson Alizarin and a touch of Yellow Ochre. While this was wet, I mixed Hooker's Green No. 1 and Cadmium Yellow Pale and painted into the bottom of the trees, then to the right and over the house. Finally, with the same colour made darker with French Ultramarine and a little Crimson Alizarin, I painted the big tree and the little one to its left with my No. 6 and rigger brushes.

Colours

French Ultramarine

Crimson Alizarin

Yellow Ochre

Cadmium Red

Hooker's Green No. 1

Cadmium Yellow Pale

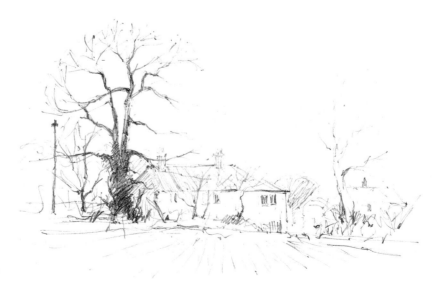

First stage ▶

56

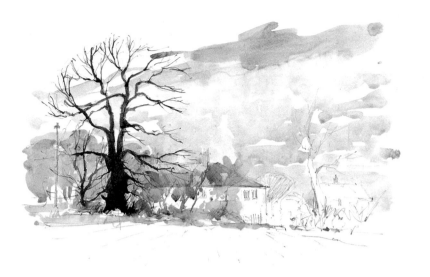

▲ Second stage

▼ **Windy Day**
2B pencil and watercolour on cartridge paper
28 x 40 cm (11 x 16 in)

Finished Stage

Using my No. 6 brush, I painted in the distant trees on the right of the house and the small house and bushes. I left the tree trunk as unpainted white paper. Next I painted in the windows and darkened the chimney pots.

The ploughed field was painted with a mix of Crimson Alizarin, Cadmium Yellow Pale and French Ultramarine and I used long brush strokes to represent the furrows. Then I painted over the branches of the big tree, working my brush strokes from left to right to suggest spring leaves blowing in the wind.

You will see that I didn't paint in the right-hand tree. This was for two reasons. Firstly, there was no need, as I could do this when I used the sketch to work from at home. Secondly, I felt it would crowd in on the house and make an archway with the other tree, and I didn't like the composition. If I used the sketch later and decided to paint the second tree, I would make it very pale (sunlit).

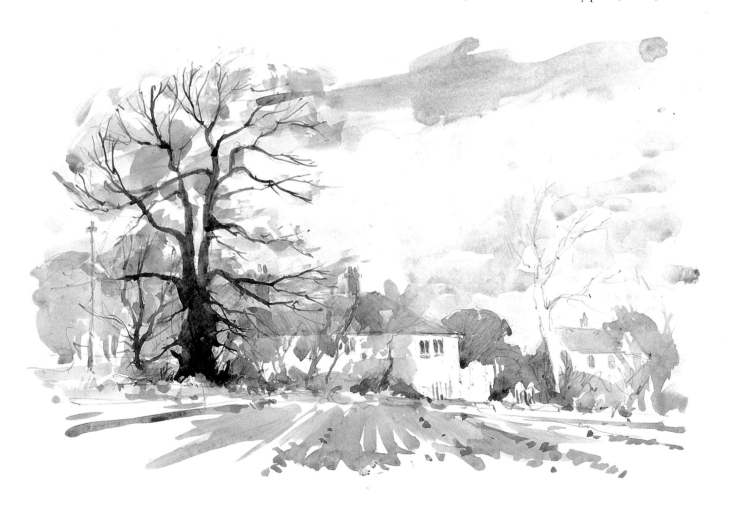

57

The Beach

I have left this sketch to last as I believe it is the most adventurous one in the book. A few different compositions could be made from this one sketch, since it covers a very large scene. Have a look at the finished stage and work out different compositions by masking off sections with pieces of paper.

First Stage

I began by positioning and drawing the large block of houses in the top left part of the sketch. Then I positioned the harbour wall. I worked to the left of these houses and then to the right, gradually creating the other houses and cliffs. I didn't put in any tonal shading – I would do this with paint later.

When the 'scene' had been drawn, I drew in the people on the beach. In real life situations, I put people in at the pencil drawing stage, as interesting groups come into my sketching area. Naturally, they are changing all the time, so you must act quickly when you see a group or a person you want to use.

Second Stage

I painted the sky with my No. 10 brush using mix of French Ultramarine and a little Crimson Alizarin, and worked down over the distant trees. Then I changed to my No. 6 brush and painted in the red roofs with Cadmium Red and a touch of Cadmium Yellow Pale.

While this was still wet, I painted the 'blue' roofs below with French Ultramarine and a little Crimson Alizarin, letting the two mixes run together in places. Next I painted the side of the red house and then the row of yellow houses, using Yellow Ochre.

Finally, I painted in the roof and windows of the left-hand house.

Colours

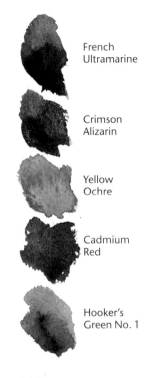

French Ultramarine

Crimson Alizarin

Yellow Ochre

Cadmium Red

Hooker's Green No. 1

Cadmium Yellow Pale

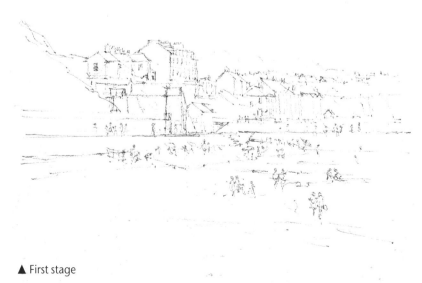

▲ First stage

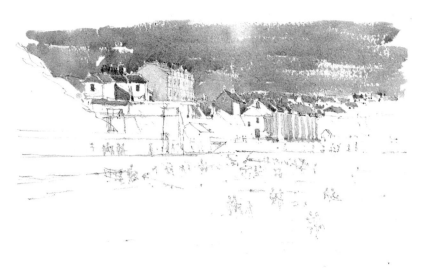

▲ Second stage

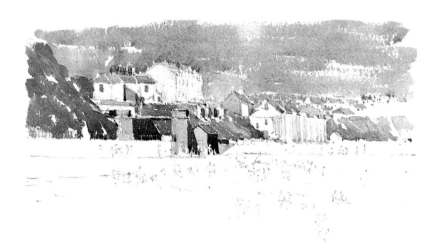

▲ Third stage

Third Stage

Using my No. 6 brush and a varying mix of Crimson Alizarin and Yellow Ochre for the cliff colour, and Hooker's Green No. 1 and Yellow Ochre for the grass, I started with the cliffs on the left and worked over to the extreme cliffs on the right. I made these paler to give a sense of distance. I kept the paint wet and worked downwards, letting the brush strokes follow the angle of the cliffs. Some unpainted white paper was left showing, which helps to give the impression of the cliffs and their steepness.

Then, with French Ultramarine, a little Crimson Alizarin and Yellow Ochre, I painted in the bridge. When this was dry, I put in the shadows using a darker colour mix.

Once you have painted an area, leave it to dry. Don't keep working over it, or it will become solid and muddy-looking. Try to let the first brush stroke (wash) also be the last – except, of course, when you go over it when it is dry with with a second wash.

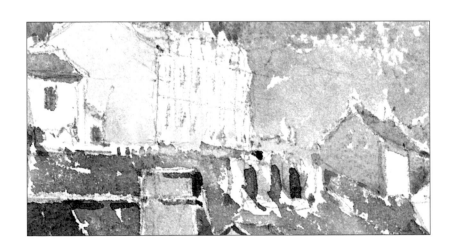

► Detail from third stage, reproduced actual size

59

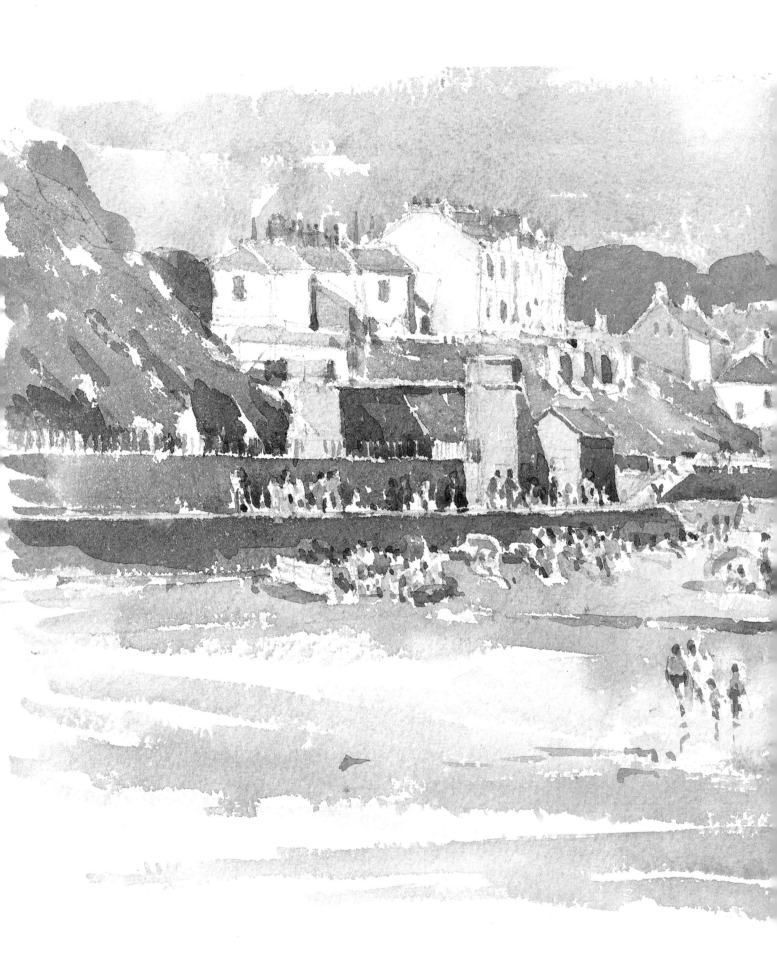

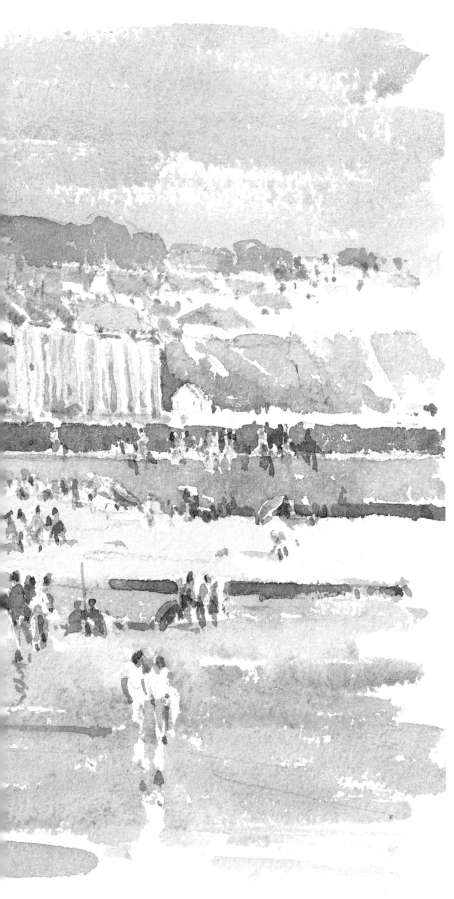

Finished Stage

Still using my No. 6 brush, I mixed French Ultramarine, Crimson Alizarin and Yellow Ochre to paint in the sea wall but used less French Ultramarine in the mix for the wall at the end of the beach.

Next I painted in the beach, starting at the top with Cadmium Yellow Pale, then running into Yellow Ochre and Crimson Alizarin, and also French Ultramarine and Crimson Alizarin for the wet parts.

Once the beach was dry, I painted in the flesh colour of the people using Cadmium Red and a touch of Cadmium Yellow Pale. When this was dry, I used bright colours to suggest their clothes, leaving plenty of white paper showing.

Then I painted in some very simple detail on the houses and cliffs, and positioned the trees behind the houses. Finally, I put dark 'blobs' to represent heads on some of the people, and a few shadows.

▲ Detail from finished stage, reproduced actual size

◄ **Dawlish Beach**
Watercolour on Bockingford paper
28 x 38 cm (11 x 15 in)

From my Sketchbook

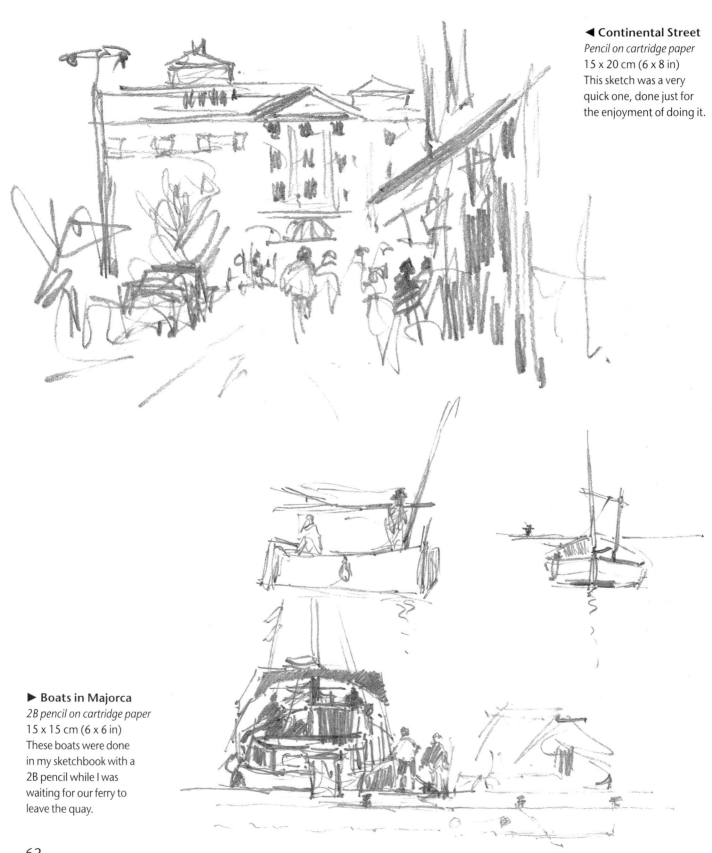

◄ **Continental Street**
Pencil on cartridge paper
15 x 20 cm (6 x 8 in)
This sketch was a very
quick one, done just for
the enjoyment of doing it.

► **Boats in Majorca**
2B pencil on cartridge paper
15 x 15 cm (6 x 6 in)
These boats were done
in my sketchbook with a
2B pencil while I was
waiting for our ferry to
leave the quay.

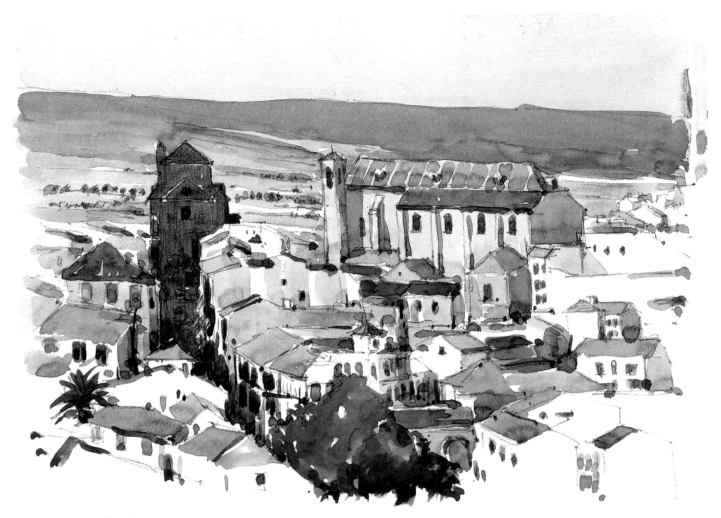

▲ Antequera, Spain
2B pencil and watercolour on cartridge paper
20 x 28 cm (8 x 11 in)
This sketch was done for a demonstration to students. I did it in my cartridge sketchbook.

◄ Cows
Pencil on cartridge paper
10 x 12.5 cm (4 x 5 in)
We were stopped in a Devon country lane by these cows being led for milking. I couldn't miss the opportunity of capturing them with my 2B pencil in my sketchbook.

Points to Remember

- Tackle simple subjects at first.

- Learn to observe – look carefully at your subject before you start sketching.

- Buy the best equipment you can afford.

- Never throw a sketch away.

- When something inspires you – sketch it!

- Put plenty of colour notes on your pencil sketches.

- Don't put notes on a watercolour sketch.

- Carry a sketchbook and pencil with you at all times and sketch as often as possible.

- Ensure that you are comfortable and warm when sketching.

- Make sure you draw enough information on your sketch.

- Enjoy your sketching – above all, it must be fun!